PAINT LIKE MONET

James Heard

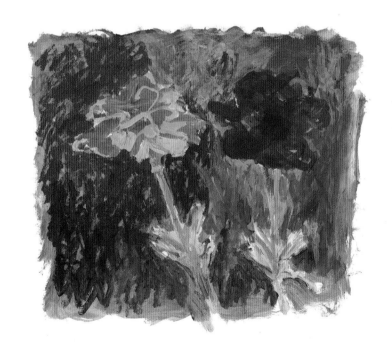

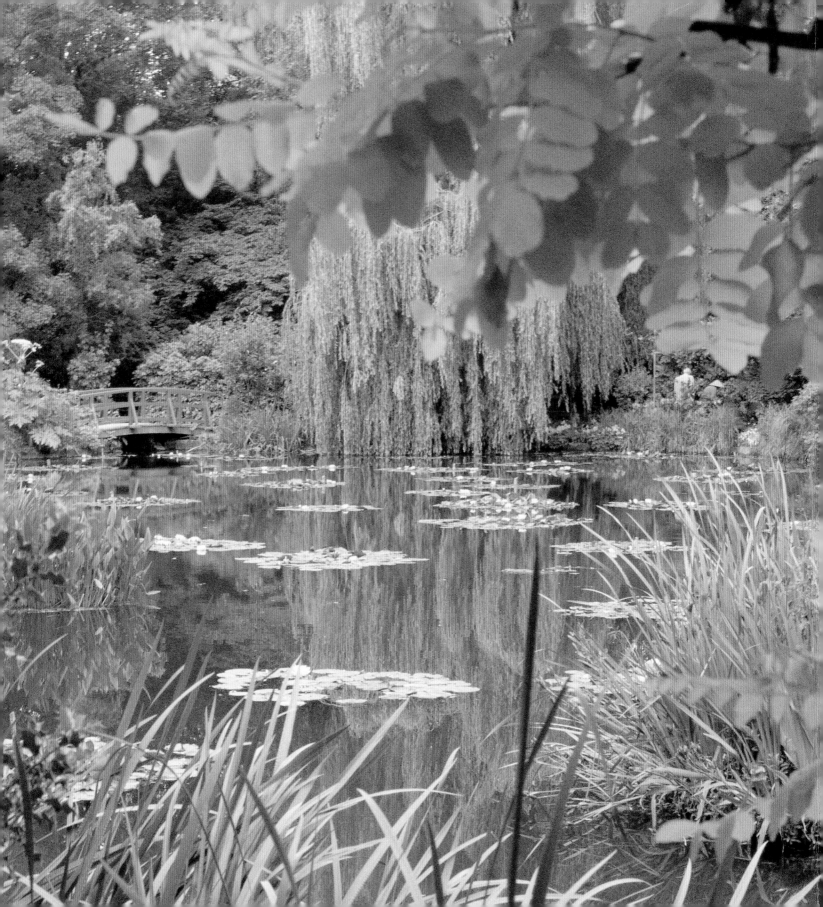

PAINT LIKE MONET

James Heard

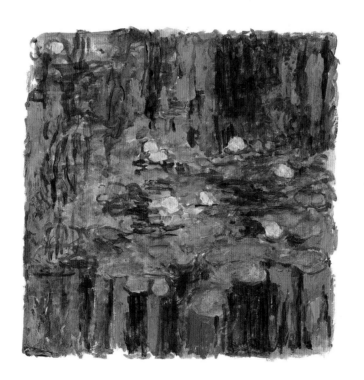

CASSELL
ILLUSTRATED

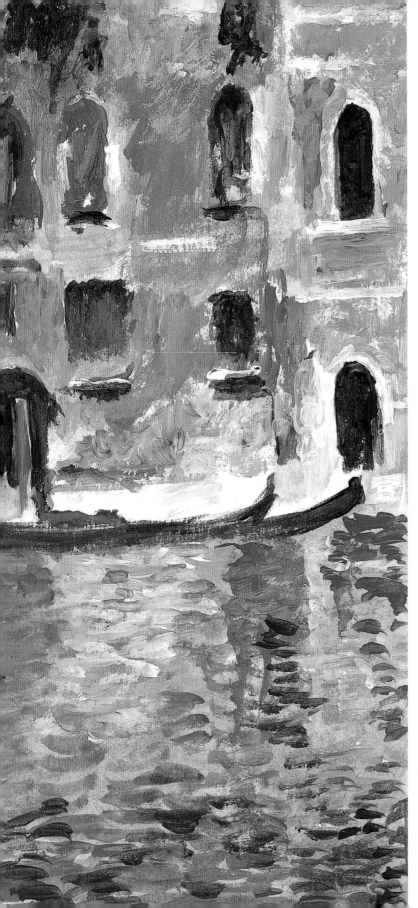

For Oliver

First published in Great Britain in 2006 by Cassell Illustrated, a division of Octopus Publishing Group Ltd. 2–4 Heron Quays, London E14 4JP

Text and design © 2006 Octopus Publishing Group Ltd
Illustrations © James Heard, unless otherwise stated

Series development, editorial, design and layouts by Essential Works Ltd

Distributed in the United States of America by Sterling Publishing Co., Inc., 387 Park Avenue South, New York, NY 10016-8810.

A CIP catalogue record for this book is available from the British Library.

ISBN -13: 978-1-844034-45-1
ISBN-10: 1-844034-45-3
10 9 8 7 6 5 4 3 2 1

Printed in China

CONTENTS

Chronology

1826 The first photograph by Niepce.

1839 Chevreul publishes *The Harmony and Contrast of Colours.*

1840 Claude Monet born in Paris.

1841 Invention of the collapsible tube.

1848 Revolution in Paris; Second Republic proclaimed.

c1845 Monet family settles in Le Havre.

1852 Restoration of the Empire; Napoleon III proclaimed Emperor.

c1856 Monet's first experience of painting *en plein air*, with Eugène Boudin.

1855 Courbet's one man exhibition – Le Réalisme.

1859 Monet studies at the Academie Suisse in Paris. Meets Pissarro.

1861–62 Monet's military service in Algeria.

1862 Monet studies with Charles Gleyre in Paris. Fellow students include Bazille, Renoir and Sisley.

1863 Monet paints in the Barbizon area. Manet paints *Déjeuner sur l'Herbe*. The Salon des Refusés is held in Paris.

1864 Gleyre closes his teaching atelier.

1865 Two of Monet's paintings are accepted at the Official Salon. He begins vast painting, *Déjeuner sur l'Herbe*.

1867 Jean Monet born to Camille Doncieux. Japanese art exhibited at the Universal Exhibition in Paris.

1868 Silver medal awarded to Monet at an exhibition in Le Havre. Lives in Etretat on the Normandy coast.

1869 Monet lives in Bougival on the Seine on the Isle de Paris.

1870 Franco-Prussian War. Third Republic. Monet marries Camille and they honeymoon in Trouville until outbreak of war. Family move to London where Monet meets up with Pissarro and the dealer Paul Durand-Ruel.

1871 Siege of Paris. The Commune. Monet returns to France and settles in Argenteuil.

1874 Monet exhibits his *Impression: Sunrise* at the first exhibition of the Impressionists.

1876 Second Impressionist exhibition.

1877 Monet paints Gare St Lazare series. Third Impressionist exhibition.

1878 Birth of Michel Monet. Family move to Vetheuil with the bankrupted Hoschede family.

1879 Death of Camille.

1880 Monet does not exhibit in the fifth Impressionist exhibition.

1881 French translation of Rood's *Modern Chromatics*. Monet rents house at Poissy with Alice Hoschede and her family.

1882 Monet exhibits at seventh Impressionist exhibition.

1883 Monet has a one-man show at Durand-Ruel. Rents house in Giverny.

1886 Monet painting in Belle-Isle. Does not participate in the eighth Impressionist exhibition. Exhibits in George Petit's fifth Exposition Internationale.

1888 Monet refuses Legion d'Honneur.

1889 Eastman's Kodak camera. Construction of the Eiffel Tower. Retrospective of Monet's work at Georges Petit's gallery in Paris. Monet organises a petition to buy Manet's *Olympia* for the State.

1890 Monet buys the house at Giverny. Paints the grain stacks and the poplar trees series paintings.

1892 Monet paints Rouen cathedral series. Begins the water lily pond at Giverny. Marries Alice Hoschede.

1894 The Lumière brothers invent the cinematograph.

1899 Monet paints the first series of the water lily pond with the Japanese bridge. Paints London scenes.

1900 Monet exhibits at Durand-Ruel.

1901 Monet acquires a motor car – a sure sign of success.

1903 Monet paints second series of water lily paintings.

1905 Fauvism first shown in Paris.

1909 Blériot's flight across the English Channel.

1906–07 Picasso paints *Les Demoiselles d'Avignon*, the painting that ushers in Cubism.

1908 Monet visits Venice.

1911 Death of second wife, Alice.

1914 First World War.
Monet starts to build new studio for the panoramic paintings of the water lily pond (*Nympheas*).

1918 Armistice.

1922 The *Nympheas* decorations presented to the State.

1923 Monet has operation for cataract on one eye.

1925 First Surrealist exhibition in Paris.

1926 Monet dies at Giverny, aged 86.

1927 Monet's twelve-panel *Nympheas* series is installed in the Orangerie in Paris.

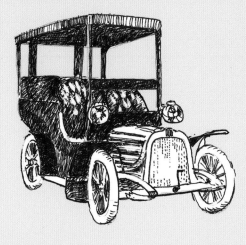

Monet's first motor car was a Panhard-Levassor. This was the first of several vehicles owned by the family.

Introduction

If one thinks of an artist, the image that first comes to mind is one of a painter working in the countryside, sketching the landscape. John Singer Sargent's delightful painting *Claude Monet Painting on the Edge of a Wood* (1888) at the Tate Gallery brilliantly conjures up this mental picture. In fact, this modern idea of the artist comes down to us from the subject of both that painting and this book – the Impressionist artist, Claude Monet.

Asked about his studio by a journalist in 1900, Monet replied that the fields were his only studios. This was not true – at his house at Giverny you can see the huge working space where he created the many paintings of his water lily pond. But Monet was making the point that, for him, working in front of the subject was a crucial part of his method.

Sargent's painting of Monet at work shows a white, primed canvas supported on a light, folding easel, with what appears to be a rectangular palette in the artist's left hand. A paint box lies on the grass beneath the easel. Interestingly, Monet sits on a folding stool, which seems to be a deliberate mark of disrespect for his old teacher Gleyre – who liked to announce to his class that 'You may sit in judgement, but you paint standing up.'

If the light was especially bright, an umbrella was placed over the canvas to reduce the glare of the white priming. There are photographs of Monet painting at Giverny under a huge parasol of the type commonly seen outside smart cafés.

The other image that is often associated with an artist is the painter's smock. To Monet and his contemporaries this uniform was in fact associated with sculptors, whose working day brought them into contact with messy materials such as wet clay, plaster or stone dust. By comparison, the painters' methods were neat and tidy until the experiments of the twentieth century.

Monet today

The freshness of Monet's radical approach has been blunted by the familiarity of his pictures through reproductions. The aim of this book is to demonstrate the less obvious, thoughtful quality behind the paintings of a man described by his friend Paul Cézanne as 'only an eye, but what an eye!'

There is information about his career, his methods and the academic system that he rejected. The core of the book is a series of analyses of Monet's paintings. These are not archaeological reconstructions, for Monet's paintings do not reveal his technical procedures even to the investigative powers of infrared photography or X-ray imaging. Confusingly, his method may change according to the subject and the lighting conditions, so we cannot always be sure exactly how he built up his paint layers in each case. There are a few unfinished canvases which offer some clues, but he generally built up his paint layers over a period of many days. Instead, each project highlights a visual problem that Monet took as his subject, for he cleverly matched his motif to the problem that he was attempting to resolve visually.

He was a landscape painter who, on occasion, would depict members of his own family and friends. In contrast to academic art where the figure dominated the canvas, Monet preferred to depict individuals at a distance as a sequence of cleverly placed brushmarks. The balance of the projects in this book follows that pattern. Two of them include figures; the remainder take as their theme water, snow or fog.

Monet painted in oil, and this book assumes that you will be using the same medium. However, it is possible to use acrylics for many of the projects, but you must not expect the same results. The drying time of oils was a problem that Monet solved when painting 'wet in wet', and his technical solution gave a distinctive look to his paintings. The range of colours used by Monet has been slightly adapted to modern requirements.

A painted detail after Monet, showing the vigorously painted dress of Camille in The Beach at Trouville *(see page 27).*

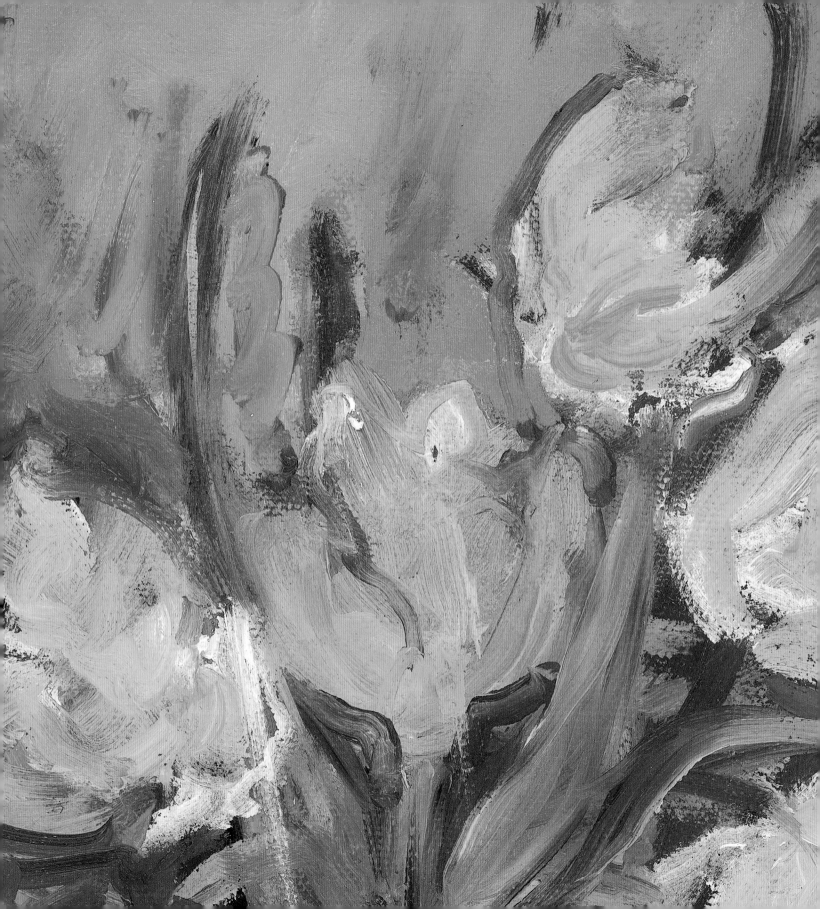

TOOLS AND MATERIALS FOR IMPRESSIONIST PAINTING

With just a few deftly placed brush strokes, flowers and stems are created. For the full image, see page 137.

Easels now and then

Historically the easel came in two styles. The simplest was the three-legged sketching easel, with a design once familiar in school rooms to support the blackboard. The nineteenth century saw the development of the studio easel, a heavy piece of equipment able to carry exhibition-size canvases up to 10 feet high.

The sketching easel was a design with an ancient history. With the rise of landscape painting came a variation – where the three legs could be folded up into the underside of a box that contained tubes of paint, palette and brushes. Advertised as 'Boîtes de Campagne' (landscape boxes), these are still made today and can be found in many art suppliers. They are convenient to carry, but extremely fiddly to erect.

At Giverny, Monet used several studio easels, as well as a series of specially made contraptions to support the huge canvases that are now housed in the Orangerie in Paris. The studio easel is considered to be a French invention. The illustration opposite shows a French studio easel from the catalogue of a late nineteenth-century artists' suppliers. This beautiful object, with its brass winding handles and casters, was the most prized piece of machinery in the studio.

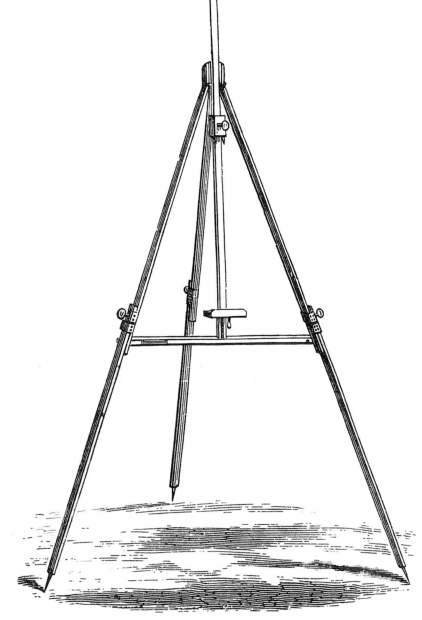

A French sketching easel from an art supplier's catalogue of c.1880. The design is identical to those in use today.

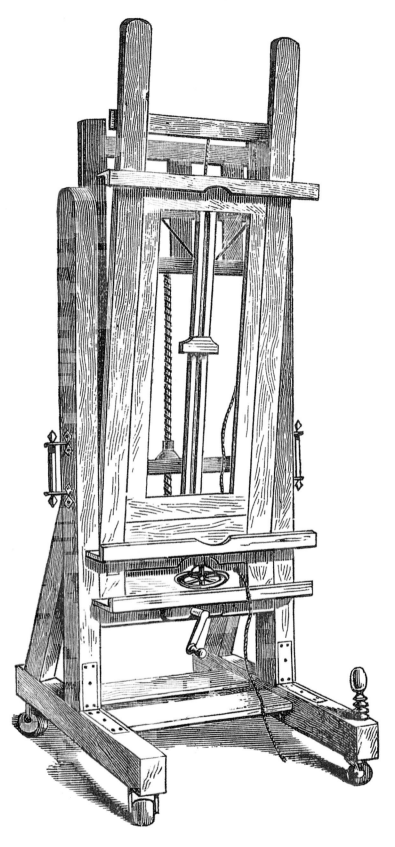

A studio easel, dating from about 1880. Monet used one similar to this at Giverny.

Monet's supports

The Impressionists occasionally stretched and primed their own canvases, but they usually purchased them ready-made from an artists' colourman. French canvases were made in three formats according to the subject matter – the figure, landscape or seascape. The three patterns were available in a large number of sizes.

The preparation of the linen canvas begins with the brushing on of warm size. This skin glue is absorbed into the cloth and prevents the oil paint from decaying the fibres.

Next, a priming of lead white is applied with a hint of pigment to soften the harshness of the white ground. The priming was usually a very pale grey or very pale yellow. One priming left the distinctive texture of the cloth, a characteristic favoured by the Impressionists. A second priming filled the interstices of the fabric and created a smoother surface for the painter.

Canvases could be bought in rolls to be prepared and stretched by the artist, bought ready primed to be stretched, or bought primed and stretched.

Traditional canvases were either nailed or pegged on to a fixed wooden frame, called a 'strainer'. If the canvas became slack it had to be removed from the frame and re-nailed.

The nineteenth-century stretcher was, however, made up of four separate pieces which fitted together with mortised joints, as shown opposite. The canvas was then nailed in the normal manner, but the tension of the canvas could be adjusted by small wedges or keys. This nineteenth-century innovation was particularly useful to the Impressionist artist who worked outside, often in damp conditions, because the canvas fibres were affected by changes in humidity. Any slack in the canvas could be taken up by simply adjusting the keys at the back of the canvas.

A large brush is used to apply the warm size. This method is still used today for unprepared canvases.

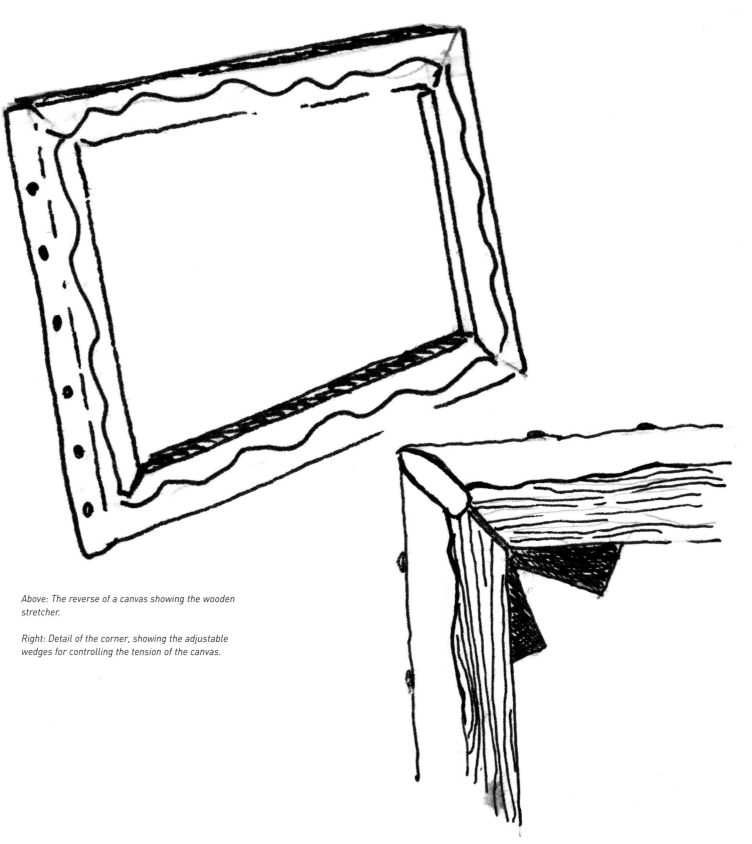

Above: The reverse of a canvas showing the wooden stretcher.

Right: Detail of the corner, showing the adjustable wedges for controlling the tension of the canvas.

Choosing a canvas

You will need at least two ready-primed canvases when painting out in the field. Monet regularly changed his canvases as the weather changed. Carrying wet paintings is a problem – this was solved by placing the canvases face to face but separated by four corks positioned at the four corners. These separators were originally wine corks. A simple strap keeps the canvases from slipping.

Only choose sizes of canvas that you can easily carry under your arm. (You can tell which Impressionist canvases were painted *en plein air* by their modest dimensions.) Make sure that your canvas is primed for oil painting, or for acrylic if that is the medium of your choosing. Some acrylic primings are suitable for oil painting. Check with your artists' supplier.

The texture of the weave is a personal choice. Some artists prefer to paint on a smooth surface, while others prefer the bite of a heavier weight canvas. It is a good idea to experiment on different textured supports. A smooth surface will take a painted line, whereas a heavy weave will break up the brush mark with the colour only coating the peaks.

Top: A brushstroke painted over a smooth canvas.
Bottom: The same brushmark painted on a coarse canvas.

Traditional methods of making oil paint

A complete history of oil painting has yet to be written, but this medium is associated with the north of Europe where the climate is often inclement, and where wooden furniture was sealed from the damp by drying oils such as linseed. The great Jan van Eyck was once credited with its invention by Giorgio Vasari (artist, collector of drawings and the first great art historian).

We know that artists were using drying oils long before the fifteenth century. To make paint, a stone slab about the size of a small drawing board was used. The artist (or more likely his studio assistant) tipped a small heap of dry pigment into the middle of the slab and next to a small quantity of drying oil. A conical grind stone, called a 'muller', which fitted comfortably in the hands and had a flat base, was then moved across the slab with a circular motion to mix together the oil and the pigment.

The idea was to coat each particle to protect it from the atmosphere. The length of time required for the so-called 'grinding' varied from colour to colour. Vermilion could be ground for many hours without injury, whereas the rich purplish blue of the expensive Ultramarine could be quickly de-saturated by over-long preparation on the slab. Paintings featuring St Luke, the patron saint of artists, often show a male assistant in the background grinding colour.

Paint was freshly made because storage systems were not effective over long periods. Sometimes the colours were placed in mussel shells or 'gallipots', and left under water.

In the nineteenth century, powered granite rollers were introduced which combined the linseed oil and pigments to a denser consistency.

Top: Hand-grinding dry pigment with a 'muller' and stone slab.
Bottom: Mechanical mixing machine with granite rollers. The paint produced by this system has a buttery consistency.

Traditional oil and landscape painting

Oil colours made in the painter's workshop were more liquid than modern paints, and working outside was so difficult that few artists considered the practice. Even the most realistic Dutch landscapes of recognisable views were made in the studio from detailed drawings. Because landscapes were produced away from the original motif, the laws of painting and the current fashions came to dominate the naturalism of the final product.

In the eighteenth century, landscape became the slave of aesthetic theories such as 'The Beautiful' and 'The Sublime', where landscape views were either controlled by classical ideas of balance or the destructive forces of storms and the like. A third category was the 'The Picturesque', which had artists and amateurs sketching views reflected in darkened mirrors to replicate the honeyed visions of the French painter Claude Lorraine.

The colours used by landscape painters were affected in the same manner. The impact of Rubens's artful use of warm and cool to create space was so great that many attempted to follow his example, but they ended up covering their foregrounds in what appeared to be a tobacco-stained glue.

The nineteenth century witnessed the arguments for and against painting certain types of landscape. Should art or nature prevail? Should landscape be the product of the imagination or a faithful record? In the first, colours and tones were manipulated to succeed in the public exhibition hall. In the second, a more truthful approach was appreciated by patrons who bought their pictures through the growing number of private galleries. Monet proclaimed his allegiance to visual truth when, on a rare occasion, he gave advice to another artist: 'When you go out to paint, try to forget the objects you have in front of you ... think here is a little square of blue, here an oblong of pink, here a streak of yellow, and paint it just as it looks to you, the exact colour and shape'.

A 'Claude' mirror was used by artists to reflect a view of the countryside. The ready-framed image was then transcribed on to paper or canvas. This device was popular in the eighteenth century.

The invention of the paint tube

The impact of the Industrial Revolution on the arts was enormous. The rising middle class, benefiting from the profits of manufacturing, invested heavily in paintings. Colourmen and artists devised new equipment, of which the most important was the collapsible tube – now found in the bathroom cabinet and the kitchen cupboard, but first devised to hold oil paint.

Certain pigments were very expensive, such as genuine ultramarine from Afghanistan, and it was difficult to avoid preparing more than was wanted. In any case, artists found the business of making their own paint tiresome and were happy to use the colourmen's pigskin bladders. However, these were not airtight and the colour could harden before it was required. Another problem was the tendency of the bladders to squirt the contents up the sleeves of the artist when opened with a sharp tack.

In 1841 John Rand, an American portrait painter working in London, devised the now familiar tube. He made an arrangement with the English paint manufacturer Winsor & Newton. Artists could now paint outside with almost as much convenience as working in the studio.

The manufacture of oil paint was changing at this time too, as described on page 17. The thicker paint made available by the new powered granite rollers was ideal for the Impressionist technique of painting quickly with short strokes of viscous colour.

A bladder with a paper label attached to the bound neck.

A collapsible tube from the 1880s.

The new paints of the nineteenth century

The nineteenth century was an epoch of dramatic changes in artists' technique, style and subject matter. The range of pigments available to the painter was significantly expanded, with Chrome Yellow, Cadmium Yellow, Cerulean Blue, Cobalt Blue, Emerald Green, Viridian Green, French Ultramarine and all the by-products of coal tar such as mauve and alizarin.

For the first time the artist was able to purchase pigments that matched the colours of the rainbow.

For the Impressionists, one of the most important discoveries was a new range of blues. This included an inexpensive version of natural ultramarine (the mineral lapis lazuli), known as French Ultramarine to distinguish it from the genuine but hugely expensive pigment. It was now possible to match the colours of the rainbow, which meant that colour theory and painter's practice could begin to connect.

Monet has not left us a complete list of his colours, but chemical analysis of his paintings has revealed a palette that by 1886 had excluded black. Instead, he relied on the 'rainbow palette' that excludes all earth colours. Monet's nine-colour palette (plus the suppressed black) shown opposite was unusual for the Impressionists. Recent investigations into a painting by Renoir revealed only seven colours, and Frans Hals on occasion restricted himself to only four.

Monet's palette / today's palette

Lead white		Titanium White – opaque
Chrome Yellow		Cadmium Lemon Yellow (lighter, greenish yellow) – opaque but transparent when applied thinly
Cadmium Yellow		Cadmium Yellow Medium (darker, more orangy yellow) – opaque, but transparent when thinly applied
Viridian Green		Viridian Green (bluish green) – transparent
Emerald Green		Emerald Green (yellowish green) – opaque
French Ultramarine		French Ultramarine (purplish blue) – transparent
Cobalt Blue		Cobalt Blue (greenish blue) – transparent
Madder Red (garance fonce)		Alizarin Crimson (bluish red) – transparent
Vermilion		Vermilion (orangey red) – opaque
Ivory Black – abandoned by Monet in the 1880s		Ivory Black – to be used only for the early projects

Brushes – old and new

Brushes are as old as the history of painting, and by the medieval period there are miniatures clearly showing small round brushes. When they were not being used, they were rested on a wooden stand. Cennino Cennini, the fifteenth-century author of a painting manual, *Il libro dell' Arte*, outlines the importance of understanding the process of making brushes and explains that there are two kinds of brushes.

Flat brushes are used for quick, wide strokes. A watercolour type brush makes fine lines.

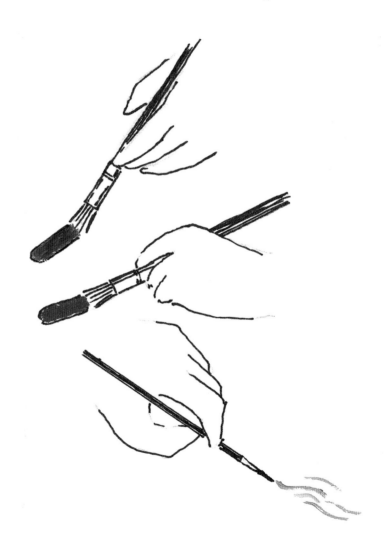

The first type was made up of squirrel hairs, carefully shaped and trimmed before being inserted into a bird's quill. This was fixed to a wooden stick. The second type was made from the hairs of the domestic pig into a large brush used for whitewashing. This softened the hairs, which were then separated and made up into smaller brushes. These hog hair brushes were secured to the handle with waxed string. For the latter, the bristles could be arranged to make a point or to give a cut-off end.

Both types of brushes remained unchanged until the nineteenth century, when the quill and the waxed string were replaced by the tin section called a 'ferrule'. Mechanical processes enabled this ferrule to be shaped in a new way. Previously, brushes were invariably round in section. Now a new shape appeared – the flat, spade-like brush that, in the hands of Monet, revolutionised painting technique.

The flat brush can be used in two ways. The first is to push oil paint across the support, in short marks of even width (see Monet's *Beach at Trouville* on page 33). The second is to turn the brush sideways, to make thinner marks.

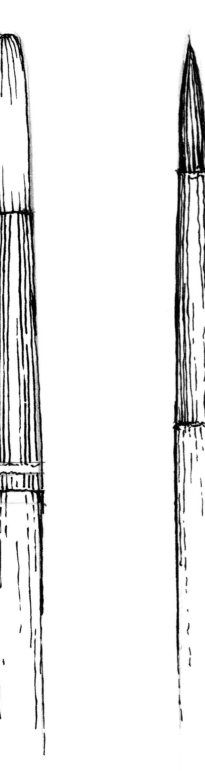

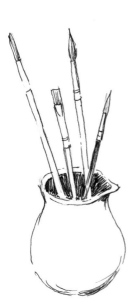

Always clean your brushes with turpentine substitute or white spirit before washing them in hot water and a domestic liquid soap. Use your fingers to shape the brushes before letting them dry. Store them upright in pots.

Left to right: Flat hog hair brush; round hog hair brush; round soft-haired brush for details.

The technical rules of painting in oil

There are two ways of approaching your painting. The first is known as 'alla prima' or direct painting, when the canvas is completed in one session. The second technique is slower because each layer must be dry before the next coat is applied. This means a drying time of several days or more. Monet was essentially an 'alla prima' painter, but if the composition was not satisfactory he would bring the canvas back to the studio and continue working.

Before starting, it is important to familiarise yourself with the palette by mixing the colours together. Begin by making up as many greens as you can from the two blues and two yellows. Then dull down each mixed green by adding small amounts of the two reds, and watch the results carefully.

There are a number of important factors to observe when using oils, which are outlined below alongside some handy hints.

1. When squeezed from the tube, oil colours are too thick for the first layer of painting (the 'lay-in'), so it is necessary to thin them with turpentine.

It is a good idea to buy a double dipper to attach to your palette. One is to contain pure turpentine to dilute the first layers, whilst the other has an equal quality of linseed oil and turpentine. Linseed oil by itself makes the paint too greasy; too much turpentine creates a matt effect.

2. The rule of painting in oil is 'fat over lean'. The first layers of your picture should be thinned with a little turpentine. This will allow the colour to dry more quickly.

3. As you build up your layers the paint film can be thicker, and the medium can be added to help manipulate the colours.

4. Thin colours dry quicker than 'fat' colours, which contain more oil. It is important that the paint films gradually thicken towards the upper layer.

5. Whether you choose the 'alla prima' method or wait for each layer to dry, it is important not to cover a tacky surface with new paint – the surface must either be completely fresh or completely dry. Painting over a tacky surface will result in cracking.

A double dipper, that clips on the palette. One container holds pure turpentine, and the other a mix of turpentine and linseed oil. The pure turpentine is to dilute the oil paint for the first layers; the linseed oil and turpentine mix is for later layers.

Checklist of materials

You will need:

- An easel that will hold your canvas in a vertical position.

- A wooden palette (or a tear-off palette of specially treated paper).

- A metal dipper to hold your mixture of oil and turpentine. The double versions are the most useful. In addition, it is useful to keep small glass pots for the same purpose when working in the studio.

- A good number of brushes. Recommended are: 6 round hog hair brushes, size 6 to 8; 6 flat hog hair brushes, size 6 to 8 and 6 watercolour brushes, size 1. Nowadays there are also excellent brushes made from synthetic materials. Go to your local art suppliers and try out some of the new nylon brushes as well as the traditional materials.

- 75 ml (US 2.5 fl.oz) tubes of artists' grade oil colours, as listed on page 21 (or the same colours for painting in acrylic). Make sure that you double up on the quantity of white.

- Palette knife. When mixing your colours together on the palette use the trowel shape with a cranked blade to stop your fingers touching the wet colours.

Palette knife with a cranked blade and palette knife with a straight blade. The trowel type is easiest to use as it keeps the fingers from touching the palette.

- Cold pressed linseed oil.

- Prepared canvases. Check that the priming is suitable for your medium of oil or acrylic. Do not buy too small a size. 12 by 12 inches is a useful size to start with. You can also buy textured paper in pads, but these are not so pleasurable to paint on.

- Best grade turpentine for thinning paint.

- White spirit for cleaning your palette.

- Plenty of rags or kitchen paper for wiping brushes and cleaning up.

- A folding stool to sit on.

Organising the colours on your palette
This is largely a matter of personal convenience, but it is usual to place white nearest the thumb hole and then to arrange the colours around the edge moving from the lightest to black on the far edge.

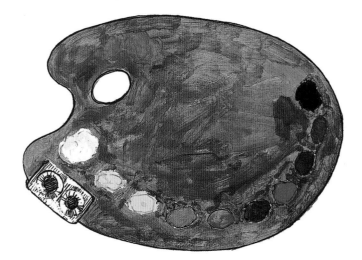

Palette laid out with Monet's colours. Note the double dipper fixed near the thumb hole.

EXERCISE:
The Beach at Trouville

Painting in oils outside the studio was regarded by conventional painters as a peculiar practice, but it is also a myth that the Impressionists completed their whole canvases on the spot. It was usual to retouch the colours back in the studio, to take into account how domestic illumination such as yellowish gas light might upset the original colour balance of the picture.

Hung on richly coloured walls in dark interiors that were quite unlike those of the twenty-first century, Impressionist pictures were to be viewed in different lighting conditions from the brilliant, harsh lighting of the open air. Another modification was the addition of human figures, or moving them around to make a better composition.

This painting of Trouville, a Normandy seaside resort that was made fashionable by Napoleon III, is an exception to the rule. It was painted entirely on the beach on a windy day. Recent conservation revealed grains of sand and small particles of broken shells which had stuck to the sticky paint.

On the left is the newly married Camille, and the woman in black is thought to be the wife of the painter Boudin. The three-year-old Jean Monet is playing on the sand out of view, but his brown slipper sits on the back of the wooden chair. On the beach between the dark cushion and middle rung of the chair-back can be seen a patch of sand grains, left in the wet oil by a thumb as Monet removed the canvas from his easel.

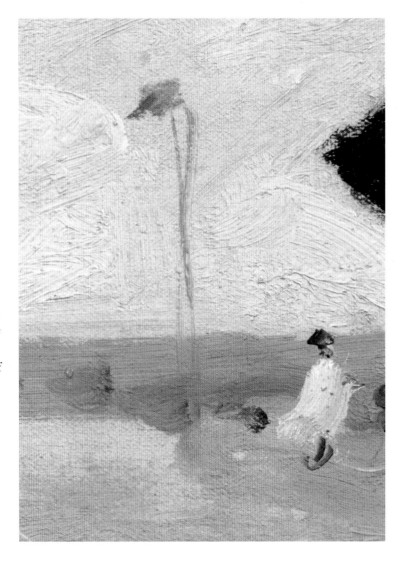

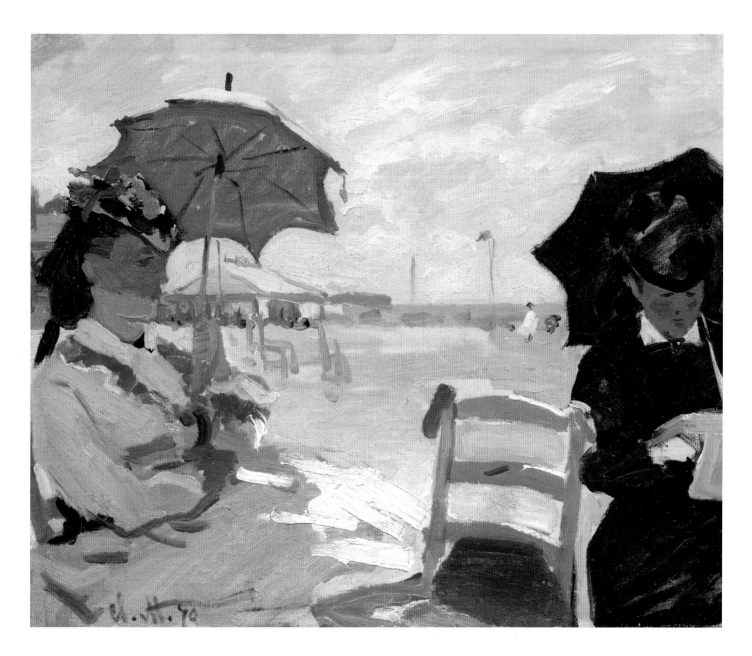

The Beach at Trouville *(1870). The Art Archive/ The National Gallery, London/John Webb*

Preparing the canvas

Now you are ready to make your version of
Monet's beach painting. Begin by preparing
a mix of Titanium White, Cadmium Yellow
and some Ivory Black to make a pale grey.
This should be painted over the white
ground of your commercially prepared
canvas. The Impressionists found that
painting on a pure white canvas made it
difficult to 'see' what was before them.
Renoir explained that the glare of the canvas
made green grass look black, as the artist
looked from the blinding white surface to
the object he was painting.

You will need:

- Palette of
 Ivory Black
 French Ultramarine
 Cobalt Blue
 Vermilion
 Alizarin Crimson
 Cadmium Yellow
 White

- Round brush
- Square brushes

*The priming here is half
completed for* The Beach
at Trouville.

Monet's innovative use of colour

Take a look at Camille's dress. The fabric is represented by slashes of thickly applied white, with less impastoed pale blue brush marks and a neutral light brown.

These colours can be explained. The dress is white in the glare of the sunlight; whereas in the shadow area cast by the parasol, the same fabric appears blue. Where the dress hangs down, the colour of the sand is reflected upwards. The traditional way of painting drapery, shown in the first diagram below, was to establish the local colour and then add a little black for the shadows and some white for the highlights.

Monet once commented that he wished he had been born blind and then in later life gained his sight so that he could see with an innocent eye. The second diagram shows this approach. He does not bother to explain how he arrives at these colours. His job is to record what his eye saw, even if it causes visual confusion.

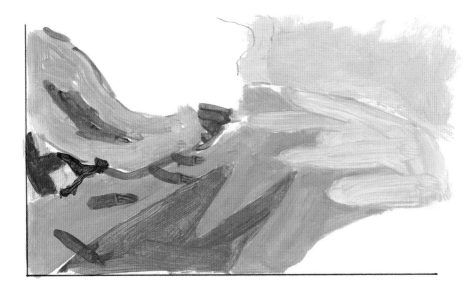

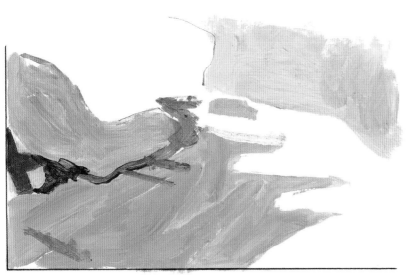

Top: A traditional method of handling fabric, using three tones of the same colour.
Bottom: Monet's approach does not explain the structure of the folds by using tonal variations of the local colour; he records the actual colours even at the risk of visual confusion.

Monet covered the canvas quickly, often leaving the colour of the priming to show through. During the first stage of painting his brush marks did not follow the form, but were slashes of colour to indicate the shapes of the main subject. The effect was lively but somewhat flat, because the modelling was indicated in the second painted layer.

It must be emphasised that Monet did not use the same method regardless of the subject matter – this is one of the key differences between his technique and that of the academic artists.

Top right: Brushstrokes of fluid paint, diluted with turpentine.
Bottom right: Dry brush marks where the paint has come straight out of the tube.

The colour of the sand and underpaint of Camille's dress (1) is mixed from the colours shown above – White, Cadmium Yellow, Vermillion and Ivory Black.

The colours for the sky are made up of two colour mixes – Cadmium Yellow and White (2) and Cobalt and White (3).

For the flesh tones (4), Cadmium Yellow, Vermillion, White and Ultramarine are mixed.

The sky uses the 'wet in wet' technique, where two or more colours are worked together. The pure white is used as a separator to prevent the pale blue and pale yellow mixing to make a green.

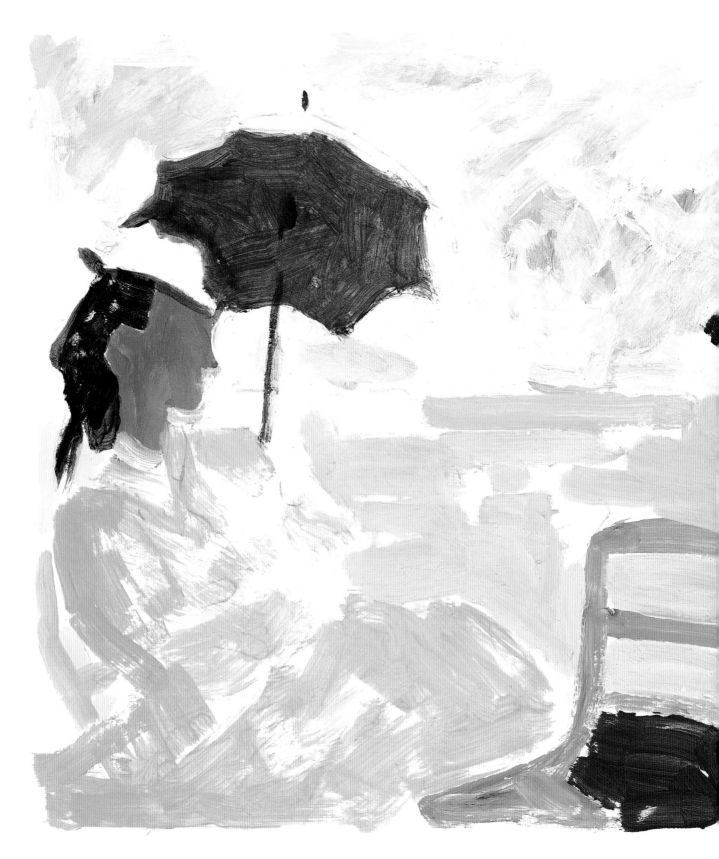

STAGE 1: THE LAY-IN

1. Using a thinnish black on a dry brush, quickly scrub in the shape of the Lady in Black (Mme Boudin). You will find that the light grey ground will show through. Use a square brush for this.

2. Mix Cadmium Yellow with a little Vermilion and a touch of Ivory Black, and brush in the shape of Camille's dress with a square brush.

 This colour will be allowed to show through for the pale brown reflection. Add White to this colour for the sand.

3. With the black indicate Camille's hair, and with Cobalt Blue shape the shadow of the parasol. Use a round brush.

4. For the blue sky use a mix of Cobalt and White, Cadmium and White, and pure White.

5. Use Cobalt and White for Mme Boudin's collar and newspaper. Use a round brush.

6. Paint a band of the Cobalt mixture for the sea.

7. Mix some Ultramarine with a little Vermilion and White for the two chairs. Use Crimson and White, plus a little Ultramarine, for the cushion.

8. Use this same mixture, with more White, for the flesh tones. Use a square brush. Put canvas aside to dry.

STAGE 2: BUILDING THE PAINT SURFACE

Using thinned paint and a soft brush, the outlines of the parasol are superimposed over its blocked-in shape.

1. Using a round brush reinforce the black areas, and paint in the parasol with a liquid paint.

2. Mix up Cobalt Blue with a little Vermilion and some White, and rough in the blue area of Camille's dress and hat. Use a square brush.

3. Use Ultramarine, Vermilion and a little White for the shadows in Camille's dress, the background chairs and the outlines of the building. Use a square brush.

4. Mix the flesh colour and add more White for the chin and neck below the veil. Use a round brush.

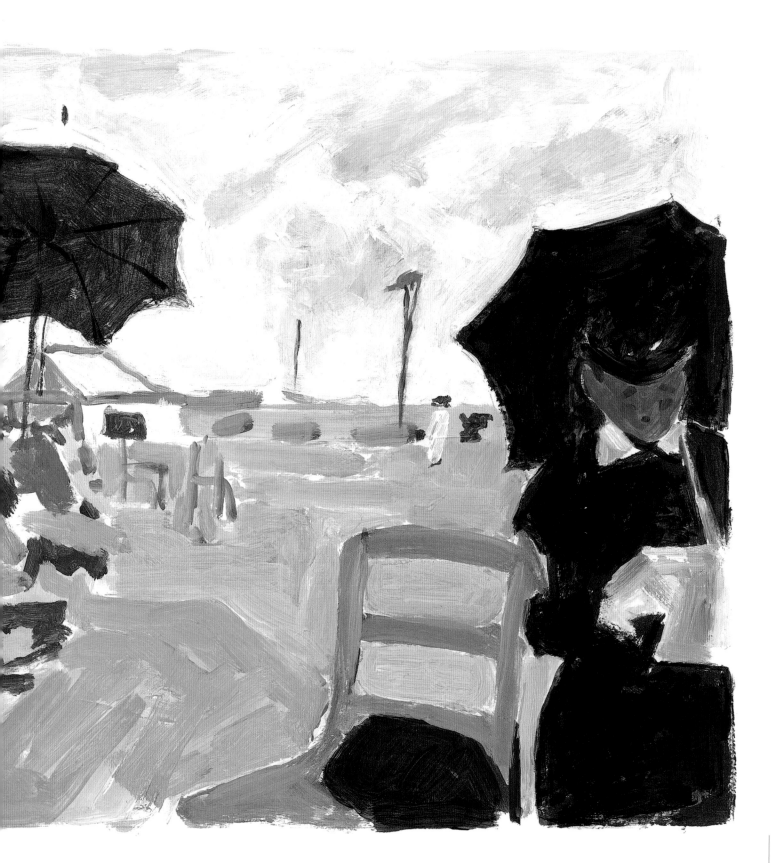

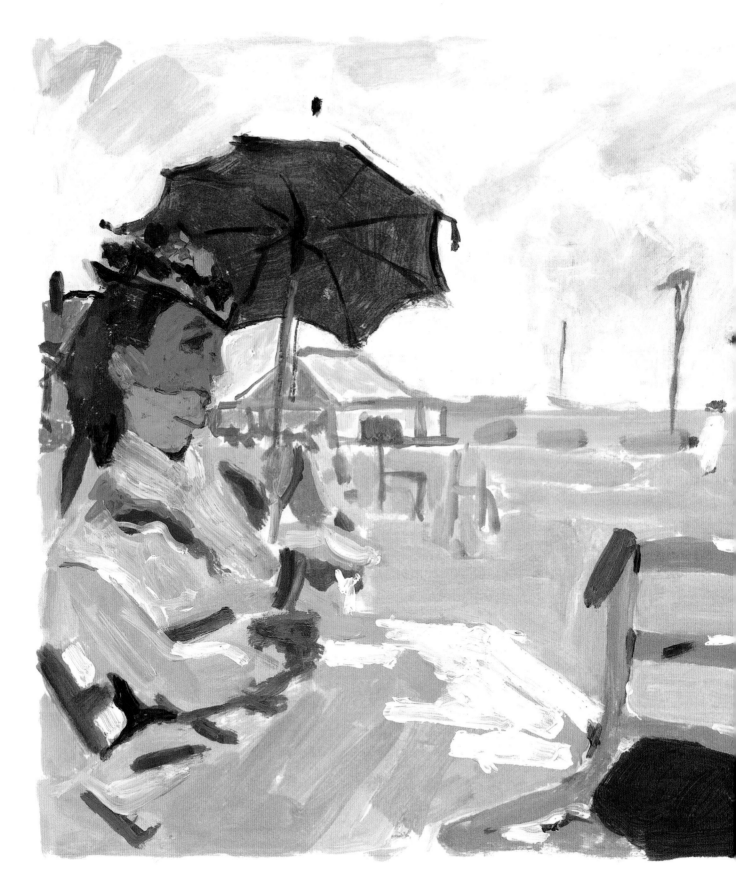

STAGE 3:
FINAL TOUCHES

1. Using White from the tube, brush in the highlights of Camille's dress with a square brush. Use a round brush for the highlights on the chair.

2. Finally, with a round brush, touch in the flowers on the hat. Use Ultramarine, Vermilion plus Ultramarine, and the mixture you used for the sand. Don't forget the eyes – Black for the lady on the right and use the cushion mixture for the eyes of Camille. The final touch is the shoe on the chair. Use a square brush and a mixture of Vermilion, Cobalt and Cadmium Yellow.

UNDERSTANDING THE ART OF CLAUDE MONET

Early life

Born in Paris, the young Monet moved with his family to the busy channel port of Le Havre, where his father inherited a grocery business. Monet's artistic talent first showed itself in the form of caricatures of his school teachers drawn, perhaps rather unwisely, on the paper covers of his exercise books. It was not long before he was exhibiting his comic drawings – or 'profiles' as he called them – in the local framemaker's shop window.

Also on show were the small beach scenes of Eugène Boudin, whose work the teenage Monet did not think much of. The older man took Monet sketching, and the pupil soon resolved to become a painter – much to the alarm of his father who then refused to fund his training in Paris.

In spite of this setback, Monet travelled to the French capital to begin his artistic education at the Académie Suisse. Here there was no formal tuition; models were provided but nothing more. Before military service cut short his studies, Monet had met Camille Pissarro who was to become a founder member of the Impressionist group.

After Monet fell ill in Algeria, his family bought him out of the army on the condition that he enrol in a conventional art school, with proper instruction. So Monet arrived at the teaching atelier of the Swiss-born Charles Gleyre, whose own paintings of classical subjects resembled coloured photographs. The training involved much drawing of plaster casts made from Roman and Greek statues, and copying in the Louvre, but although Gleyre stressed the importance of the human figure, he did not dismiss landscape painting.

Gleyre had something else of value to teach Monet and that was the importance of originality – but perhaps the greatest benefit to Monet was the friendship of his fellow students, Auguste Renoir, Frédéric Bazille and Alfred Sisley.

A French art student copying from a plaster cast.

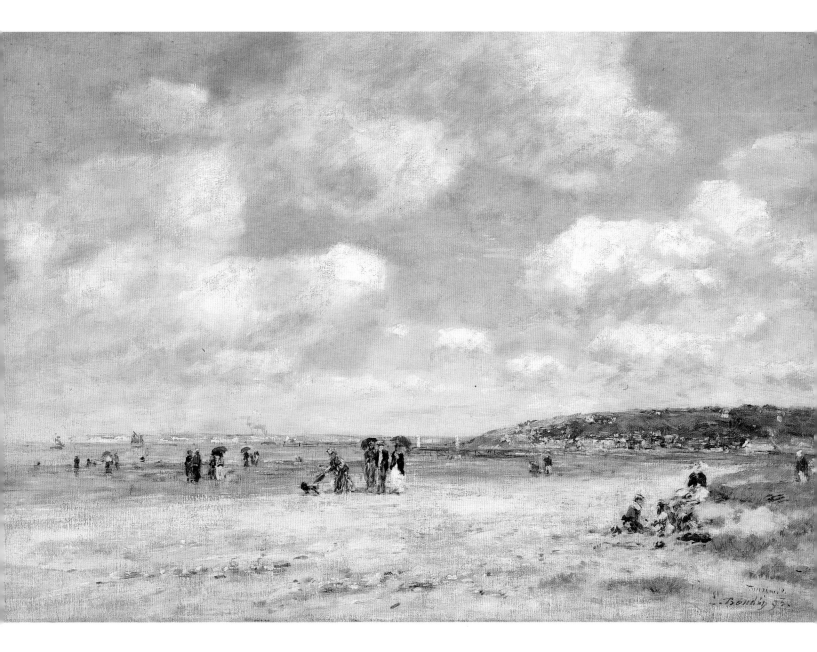

Eugène Boudin: The Beach at Tourgéville-les-Sablons *(1893). Art Archive/ National Gallery, London/John Webb*

Impressionism and the science of colour

The Impressionists tried to reconcile the difference between the coloured pigments on their palettes with the coloured light that illuminated their subjects. When colours are mixed together they become darker. In theory the three primaries – an exact red, a middle blue and a pure yellow – should combine to make black, whereas coloured light behaves in a different way. Light primaries are red, magenta and green. When fused they mix to white, hence their name 'additive colours'.

The problem for the Impressionists was how to resolve this difference. The American chemist Ogden Rood described additive and subtractive colours in his *Modern Chromatics* of 1879, which was translated into French in 1881. He pioneered the colour top. Printed with a simple colour wheel on the surface of the wooden disc, the top was spun like a child's toy. As it gained speed the colours fused into near white. He demonstrated that it was possible to replicate the effect of additive colours by rotating subtractive colours at speed.

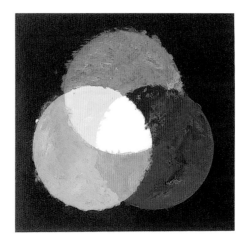

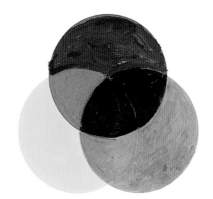

Top: Additive colours – where the three colour primaries (red, magents and green) add up to make white if projected against a black wall.

Bottom: Subtractive colours – where pigments mixed together result in black, or near black. Light is therefore subtracted.

The Impressionists were not driven
by theories of art or physics, but their
answer to the problem of mimicking
light with subtractive colours was to
break down their stripes of pure colour
into small brush marks, and to combine
them with other colours to create an
optical fizz. Instead of juxtaposing tones
of light and dark, the Impressionists found
a way of scrambling pure colours to give
the appearance of light itself. This mingling
of bright colours created an effect of light
in the eye of the viewer.

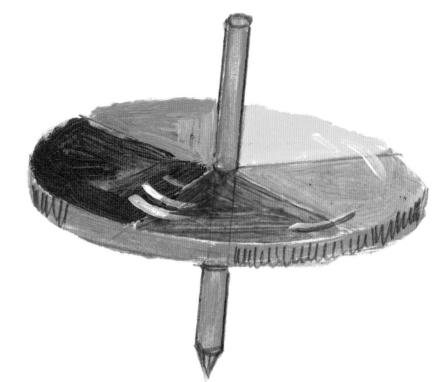

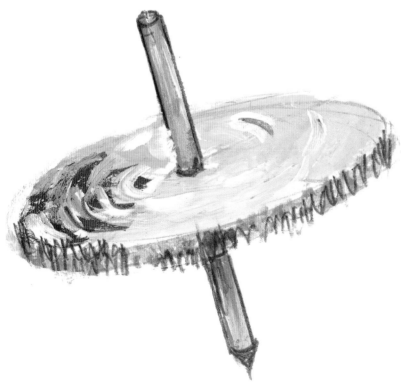

*Ogden Rood's spinning tops were printed with a
colour wheel in subtractive printing inks. When
spun, the subtractive colours appeared to blend
into a near white. Through this device, subtractive
colours behaved like additive colours.*

Changing colour

The Impressionists' attitude to colour was changed from those earlier artists by simply moving from the studio to the open fields where the light was strikingly different. Artists working before the Impressionists had worked in studios or workshops whose windows faced north because they needed to exclude the distracting rays of the sun and the visually disturbing patterns of reflected light.

When the Impressionists took their oil paints to work in the open air, they noted that the warm light of the sun resulted in cool shadows – the reverse of the studio situation. Astonished by the blueness of the atmosphere, Monet and his colleagues started to emphasise the cool side of their palette.

They also changed their technique. Instead of blocking in the composition in tones of brown, they reversed the traditional method and mapped out the picture in nuances of blue. Painters such as Rubens and Velasquez built up their paintings from a base of warm brown underpainting to the final layer of cool highlights. Monet moved from the cool, near-white priming of his canvases and blue lay-in to warm final touches.

North light is cold but produces warm shadows according to the laws of colour. Blue and orange are complementary so that the bluish northern light will give warmish shadows. This effect can be found in Rembrandt, and was used not only by portrait painters but also landscape artists following the method developed for figure painting. This so dominated Western art that landscape artists followed the same procedure almost out of force of habit, using warm brown shadows amongst their greens.

Warm sunlight shining on an object casts a cold (blue) shadow. Coloured shadows are not always evident. When the surface on which the shadow is cast is neutral the colour can be discerned. A blue shadow from a setting sun is obvious when cast across snow or a grey pavement but will not show up against grass. The greenness will overpower the much more subtle shadow.

North light produces a warm shadow. The cool light from the North has determined the look of European painting for hundreds of years. Only the insistence of the Impressionists on painting outdoors suggested that there might be another approach.

Eugène Chevreul

In charge of the dye works of the Gobelins tapestry factory in Paris was the great chemist Eugène Chevreul, who realised that many of the difficulties of making the correct colour of a thread were not connected so much to chemistry as to the laws of physics. His researches were published in 1839 in the seminal volume, *The Harmony and Contrast of Colours*.

Chevreul's book contained a colour circle divided into 72 segments, which enabled the painter, designer or printer to check the exact complementary of any given colour. Thus a greenish blue lay opposite an orangey red. For the Impressionist this information was crucial because they were juxtaposing colours instead of opposing light and dark. How much the Impressionists studied Chevreul's text is open to question. His pioneering work was influential, and abridged versions were widely available.

One important lesson clearly understood by the Impressionists was Chevreul's law stating that 'Two adjacent colours seen by the eye will appear as dissimilar as possible'. Laying down vivid colours side by side, brush mark next to brush mark, was a dangerous game because one hue would always affect the appearance of the other.

A pure colour could make a mixed colour appear to be dirty, and a light colour could push a greyish tone towards black. The pure colours could bully the more neutral tints.

A simplified version of Chevreul's colour circle.

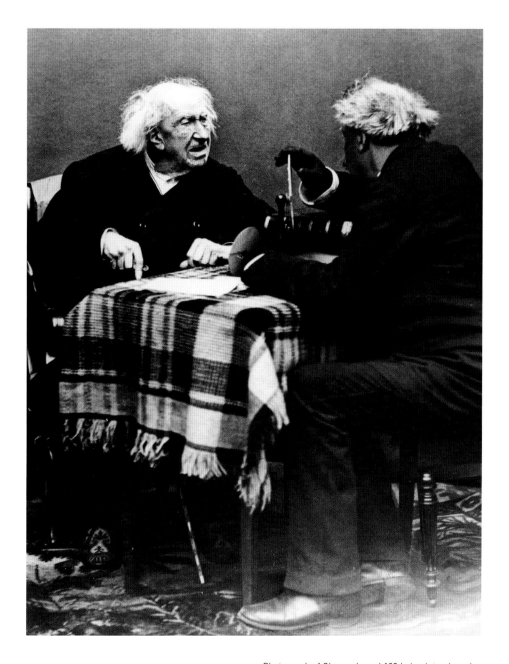

Two rectangles of grey are set against different backgrounds to demonstrate that the same neutral colour can be affected by adjacent hues.

Photograph of Chevreul aged 103 being interviewed by the son of Nadar, the pioneering photographer. Notice the colour top on the table (see page 43). The Art Archive

EXERCISE:
The Magpie

If water was the Impressionist's greatest challenge, painting snow was a revelation. Working outside they began to understand how shadows were not simply dark, uninteresting areas of grey or brown. The idea of dark shadows was partly the result of using the Claude mirror (page 18). The convex glass would transform the scene into an image reminiscent of seventeenth-century Italianate landscapes with their honeyed tones. The Impressionists introduced the picture-loving public to the correct optical balance of warm and cool light in nature.

According to the laws of colour, the shadow of an object relates to the colour of the light source. Absolutely white light gives a black shadow, but in nature the sun is never truly white. The yellow rays give purplish shadows whilst the orangey sun of winter changes them to blue. Look at the colour circle on page 46.

In 1868, the year of this painting, Monet was observed painting in the deep snow. He was wearing gloves and three coats, and at the foot of his easel was a foot warmer. Doubts have been expressed about whether *The Magpie* was actually painted outside because of its large size. Whatever may be the case, the observation of the colours in the snow is remarkable. This is one of the first of Monet's paintings to demonstrate the coloured shadows that were so characteristic of Impressionism.

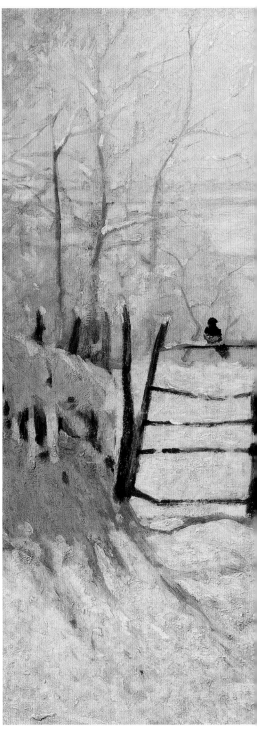

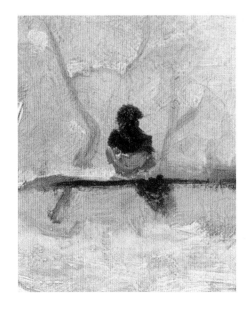

The Magpie *(c.1868–69). The Art Archive/ Musée d'Orsay, Paris/Dagli Orti*

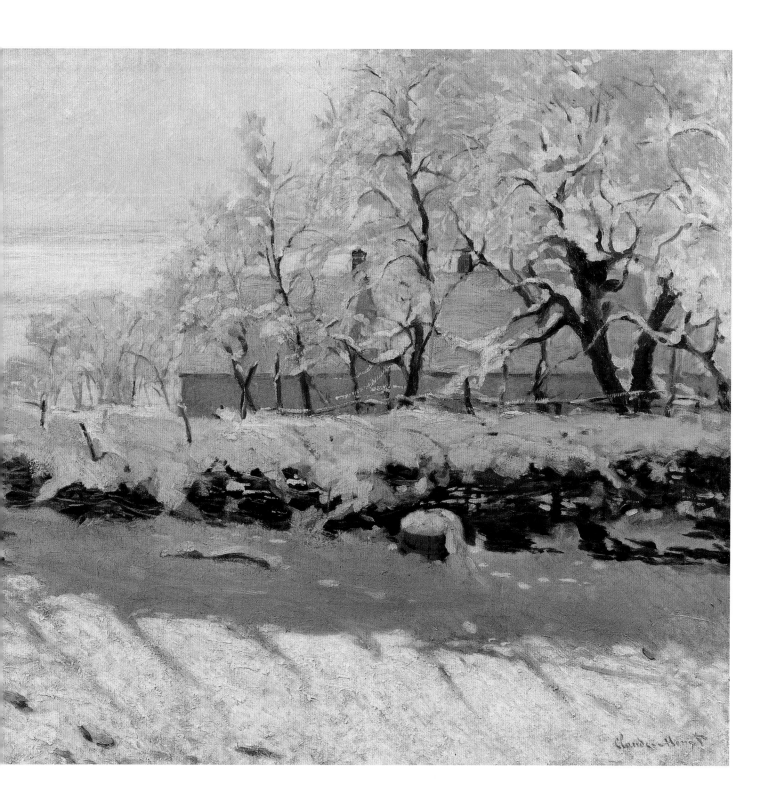

STAGE 1: THE LAY-IN

1. Mix up two whites – a warmish yellowish off-white for the sky, and pale Ultramarine for the shadows.

2. Block in the two whites using a round brush. Try to keep your colours as close to white as possible, but at the same time differentiating between a warm white and a cool white. This is the core of the painting – the subtle contrast of the warmly illuminated sky and the cold shadows. Leave spaces for the walls and chimney of the cottages and the garden wall.

STAGE 2: BUILDING UP THE DESIGN

1. Make a dull orange by combining Cadmium Red, Yellow and White. To neutralise its vivid character add a little Ultramarine.

2. Using round brushes to block in the two whites, quickly apply the tints to keep the areas lively and to avoid the 'poster' effect of flat colours.

3. Now make a dull orange by combining Cadmium Red, Cadmium Yellow and white. To neutralise the vivid character, tone down the mix with a little Ultramarine. Use a square brush to paint the pale orange roof. You will find that this flat brush is good for working up to straight edges.

4. It may seem a little odd to leave the dark wall to this stage, but the balance of the picture is determined by the warm and cool whites. The wall acts as a dark correcting balance between the two somewhat saccharine tints. Use this same colour for the trees.

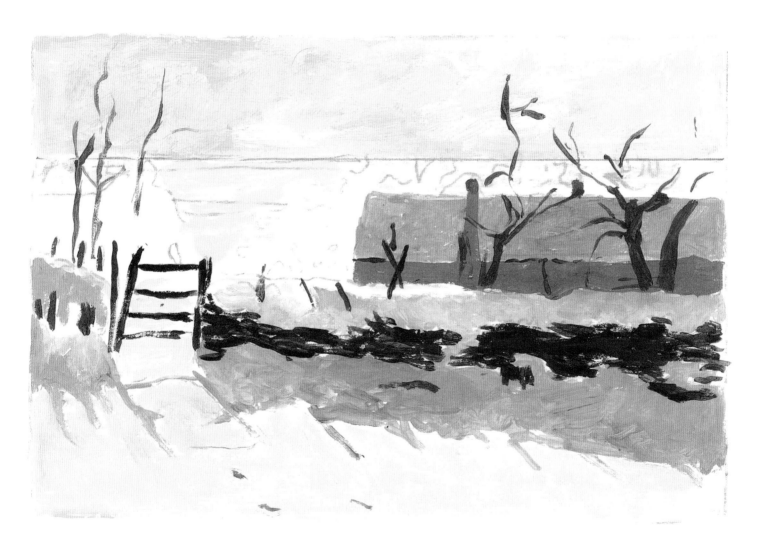

STAGE 3: FINAL TOUCHES

1. Build in variation into the sky area and also the white snow in the foreground. The blue shadow of the garden wall needs to be broken up with patches of white.

2. The light on the snow-covered walls now needs attention. Bulk out the wintry branches of the trees with a faintly purplish hue. Don't forget the dark accent provided by the black plumage of the magpie.

3. Using a fine brush and black paint, place a blob on the top stile of the gate for the magpie. Add a smaller spot for the head. When dry, make up a greyish white for the body of the bird.

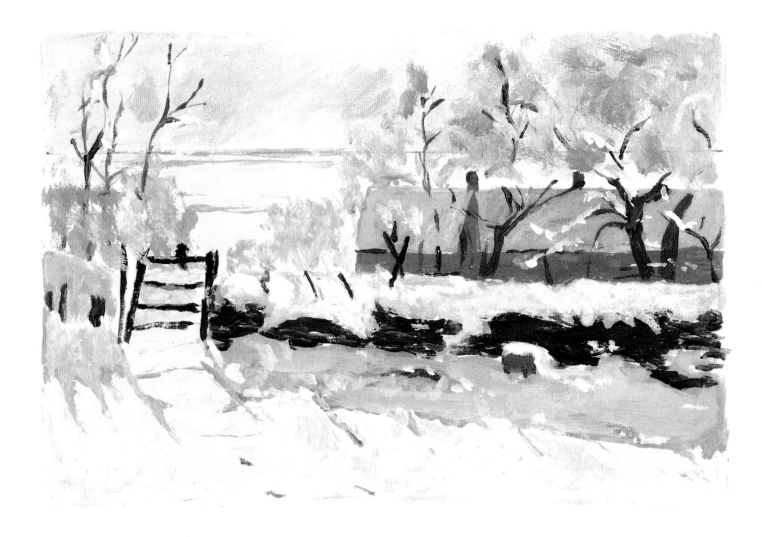

An essay in whites

The challenge of painting a wintry scene is that of finding a solution to the subtlety of the contrasts between the bluish shadows and the warm, white sky.

The idea behind this section is to give you an alternative to going out into the snow to paint.

Arrange some hen's eggs on a white plate. (I have added a head of garlic for variety of shape and texture.) The plate needs to be placed on a dark background. This project uses the palette recommended on page 21.

Notice how the highlights are cold, and how the shadow areas or half-tones reveal the warm colour of the eggs. If you cannot see bluish shadows, try using a tinted light bulb in a desk lamp to replicate the effect of the warm winter sun.

To achieve the very pale colours, you may find that you need first to mix up the local colour for the eggs – pale brown or cream. Whilst the colour is still wet, work in some white for the highlights.

The cool shadows can be painted with a slightly darker blue than you need. Once the film is dry, go over it with a scumble of white. This effect uses a dryish mixture of white which is scuffed over the darker colour.

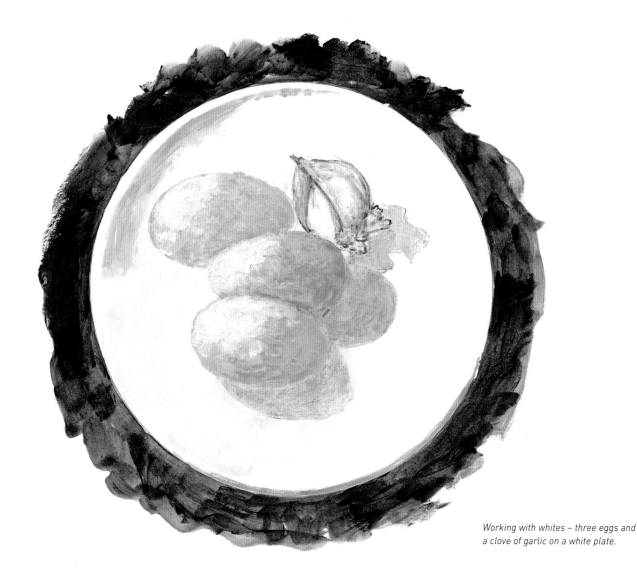

Working with whites – three eggs and a clove of garlic on a white plate.

Monet and Japanese prints

In 1862 a shop selling oriental articles opened in the elegant Rue de Rivoli, in the centre of Paris. La Porte Chinoise was patronised by many artists. Purchased from this avant-garde store, porcelain, Japanese kimonos and fans began to appear as props in paintings by the ex-patriate American artist Whistler. His fellow artist Degas was more interested in the Japanese print, and not only began to borrow the various themes but cleverly began to adapt the compositions for his own paintings. This interest in Japanese art was furthered by the displays at the Exposition Universelles, the first appearing in the Exposition of 1867.

Monet was an early enthusiast for Japanese prints, which he was able to buy in Le Havre, the port of entry into France for goods from the Far East. He began to collect these coloured woodcuts, which were framed up and displayed in the house at Giverny.

Amongst his collection was Hokusai's *One Hundred Views of Mount Fuji*. Prints by other artists featured snow scenes, bridges and perpendicular rocks surrounded by raging seas, all motifs explored by Monet. He even painted his wife Camille dressed in a kimono to cash in on the craze. Later, he abandoned such direct reference and began to explore the off-centre compositions and daring perspectives of the Ukiyoe woodcuts.

The famous curved bridge over Monet's lily pond is directly inspired by the many prints of the same subject by Hokusai. At the end of his life Monet admitted that the appeal of the artists who designed the woodcuts was that they 'taught us to compose differently'.

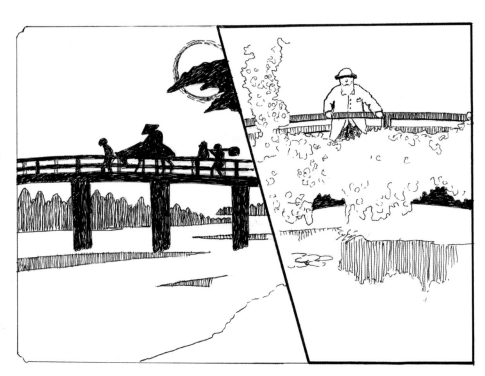

This illustration combines a photograph of Monet on the Japanese Bridge at Giverny with Hiroshige's Moonlight, Nagakubo (c.1840).

Early years

When Gleyre closed his studio due to ill health, the group of young painters we now know as the Impressionists decided to leave Paris and learn how to paint landscapes in and around the village of Chailly, some 50 miles southeast of Paris. The next village, Barbizon, gave its name to a school of landscape artists who preferred to take their easels into the local woods and to the flat plains.

Barbizon provided cheap lodging, easy access to Paris on the railway, and a community of artists including Millet, renowned for his studies of peasant life, and the great landscape painter Corot. Rejecting the lessons learned in Paris, Monet and his friends learnt from the supportive advice freely given by the older generation – Corot, Courbet and Millet. Diaz, another Barbizon painter, even rescued Renoir from the taunts of some local louts.

The Barbizon painters usually finished their pictures in the studio, but Monet took painting *en plein air* to extremes. In 1865 he dug a trench in the garden so that he could work on all parts of a large canvas which included the woman who was to become his wife, Camille Doncieu. She appeared in three different poses in *Women in the Garden*, a canvas rejected by the Salon of 1867. On the jury was none other than Jean-Léon Gerôme – painter, sculptor and arch enemy of the Impressionists.

To be a *refusé* (an artist rejected by the Salon – see page 72) meant an uncertain future, and Monet never knew where the next meal was coming from. His friend Bazille bought *Women in the Garden* in instalments. Two years later Monet wrote to Bazille about his still desperate situation, to which suicide by drowning seemed to be the only answer.

By the end of the year he was living outside Le Havre, at Etretat, with Camille and their young son Jean. In the same year, the Friends of Art in Le Havre awarded him a silver medal. By 1870, when the Franco-Prussian War interrupted his stay in Trouville, Monet was working in a mature Impressionist style. Whilst Renoir and Bazille went off to fight, Monet left for London where he was joined by Pissarro. They had no better luck with the Royal Academy than they did with the Salon back in Paris. Although their work was rejected, Monet met Paul Durand-Ruel, the dealer who was to support the Impressionists. 'Without him we would have starved to death,' remembered Monet in later years.

Drawing after The Bench. *This painting of Camille by Monet dates from c.1873.*

EXERCISE:
The Regatta at Argenteuil

The study of water is central to Monet's art, and in 1871 he was back in France, settling with his family in Argenteuil on the river Seine. Life in the 'little house' was comfortable, for by this time Durand-Ruel was selling Monet's paintings at prices that enabled him to employ servants. During his seven years in Argenteuil Monet painted nearly 200 canvases of this suburb of Paris, and his views began to include symbols of modern life, such as railway carriages and factory chimneys.

Painting water changed Monet's brush mark into a small comma in order to capture the sparkle of river. To help him analyse the endlessly moving reflections, Monet built a studio boat.

All things English became chic in Paris in the nineteenth century, such as English tailoring, English gardens and English recreations. Yachting on the Seine was part of this craze, and provided Monet with an enduring image of summery tranquillity – although his personal circumstances were far from happy. Months later he was writing to Manet to admit that the family's credit at the butcher and the baker had finally run out.

In spite of this, Monet had the character to rise above the trials of everyday life to face the challenge of painting water, a subject that has produced some of the most startling images of the Impressionist School. He fully understood how light can reveal the structure of the undulating surface of a gently moving river. Even the Venetian Canaletto, a sophisticated artist who lived surrounded by water, failed to describe the phenomenon, instead merely relying on a simple graphic symbol.

The Regatta at Argenteuil *(1872).*
The Art Archive/ Musée d'Orsay, Paris/ Dagli Orti

Waves

Monet recognised that a wave follows the rule fundamental to landscape painting. Planes reflect light according to how they are angled towards the light source. The trough and top edge of the wave will catch the light, whilst the wall will be in shadow. The darker blue of the painted water represents those parts of the gentle wavelets in shadow. This may not seem particularly adventurous, but Monet had learned from the Dutch sea painters as well as Turner, who understood the sea better than any painter before or after him.

Of course other factors affect the colours and tones of water. Mud or sand stirred from the river bed or floor of the ocean, conditions of the sky cover and the waywardness of currents all contribute to create their own modifications. The suggestions here on how to paint a wave are therefore a generalisation.

Top: Canaletto's graphic wave is surprisingly childlike for such a sophisticated painter.

Bottom: A wave as observed by Monet. The lights and darks lucidly convey the form of the wave. The trough and the crest face the light, whilst the vertical wall is in shadow.

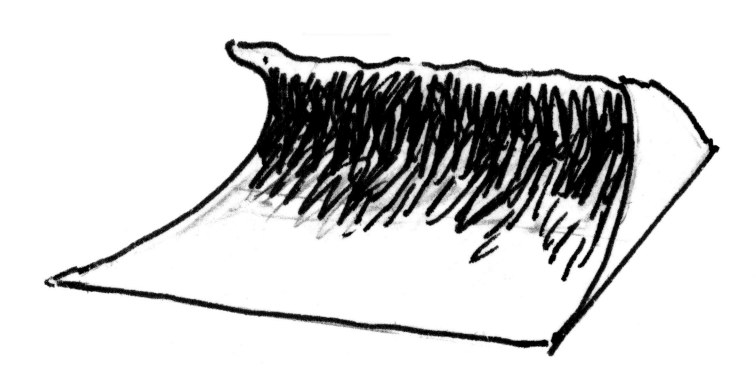

Reflections

Reflections are like hinges – the angle of incidence is equal to the angle of reflection. This is why the water in the foreground is a deeper blue than by the bank. The water nearest to us reflects the blue of the zenith, whilst the more distant reflections mirror the pale colour just above the horizon.

The objects reflected in moving water appear to disintegrate, whilst those in a mirror are not distorted. The reason for this is the curving surface of the water.

Top: The eye looking at the reflection of the horizon. Notice that the angles match each other so that a shallow angle of vision will show the pale horizon.

Middle: Here the eye is looking down from an acute angle, which will reflect the blue of the zenith.

Bottom: Diagram to show how reflections are broken up. The shape of the waves changes the angle of incidence so that the curving water reflects slightly different parts of the sky or buildings.

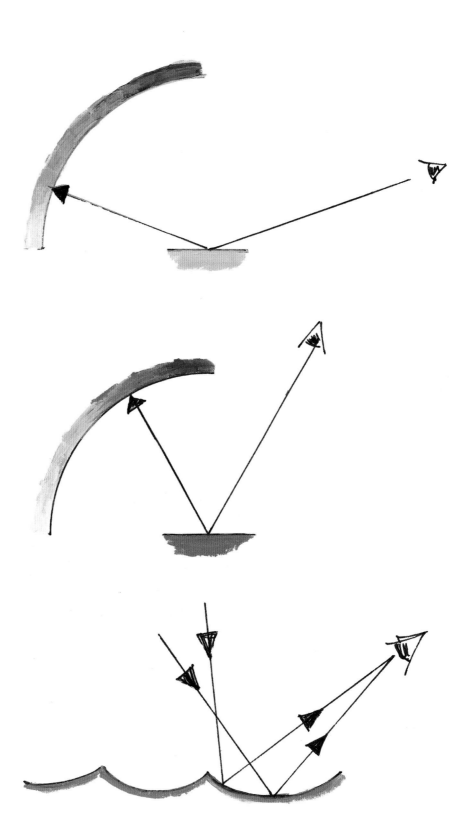

STAGE 1: BLOCKING IN THE SKY AND WATER

1. Quickly brush Ultramarine tinted with White into pure White to establish the sky. (The warm yellow appearing at the bottom and far right may be a painting underneath. Monet has decided to re-use an old canvas.)

2. Reserve empty shapes for the triangular sails of the yachts, the trees and the red house on the hill.

It may seem odd to leave a gap, but this allows the white priming to play its part in creating luminosity, which occurs when the light travels through the paint layers to the white base colour and bounces back through the upper layer. The idea is that light comes from behind to illuminate the upper layers.

3. The relationship between sky and water is made clear by their shared colour. Block in the palest tint of the water with the same colours as the sky, making sure that the top of the sky and the bottom edge of the water is the bluest to conform with the rule on reflections.

STAGE 2: BUILDING THE STRUCTURE

1. Dip your brush into the oil and turpentine mixture, and pick up some Ultramarine mixed with a little White. Make fluid brushstrokes for the shadows and the water.

2. Mix Ultramarine and Lemon Yellow for the greenery, and mix Lemon and White for the sails and the reflections.

3. Draw in the houses and their reflections with Vermilion and Lemon mixed.

STAGE 3: FINAL TOUCHES

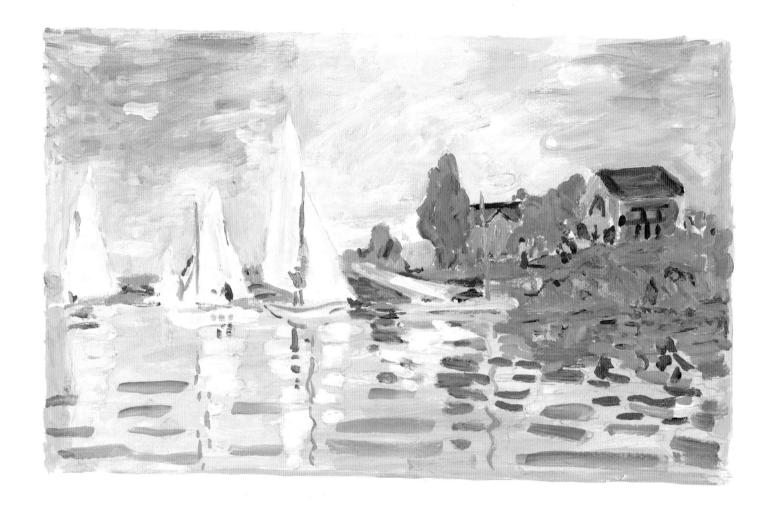

1. Add the reflections of the trees and riverbank.

2. Create a brown colour by adding Vermilion to your green mix, and mark in the tiny figures between the houses.

3. The yacht with its sails furled was an afterthought. Now is the moment to paint it in.

4. Finish with the orangey lines of the masts and their reflections.

Your own painting of reflections

Monet had a remarkable eye for the lights and darks of water or any reflective surface. To practise your skills of mixing the right tone and arranging these patches to suggest the sparkle of liquid or the polish of a silver cup, remove the paper wrapping from a tin can. Just using black, white and greys, make a study of the metal cylinder.

Monet's colleague Camille Pissarro gave this advice to a young painter: 'Drawing is a brush mark of the right tone and colour'. Notice that, to achieve a glint, you must use pure white on a grey background. If your highlight does not seem to shimmer, try placing a fine line of black along it.

When you come to paint reflections in water remember that, although you are using colour, it is the correct pattern of lights and darks that does the trick. Study reflections from the great painters of water – Claude Lorraine, J.M.W. Turner and Monet.

A study in reflections. A tin stripped of its label is good to practise on.

Painting *en plein air*

The Impressionists were not the first to take their oil paints into the fields to paint directly from nature. As early as the seventeenth century there was already equipment designed for painting outdoors, and evidence that Claude Lorraine, the French artist working in Rome at that time, may have been the pioneer of working *en plein air*.

In the eighteenth century another Frenchman, François Desportes (who specialised in still lives of dead game), certainly painted direct from the motif, always taking with him a simple easel and a metal painting box. By the end of the century, painting outside was commonplace, and Pierre Henri Valenciennes even wrote a treatise about the practice. However, his excitingly fresh landscapes of the countryside around Rome have little connection with his carefully finished exhibition pieces. Such sketches were the equivalent of exercises on the piano, and there are plenty of surviving études from the eighteenth century. Well-known examples are the cloud sketches by Turner and Constable in England, and by Delacroix and Michallon in France.

What was new about the Impressionists' paintings *en plein air* was that the canvas was worked on outside and was not intended as a sketch. The whole process of painting was carried out in the field or, in the case of Monet, on the water in his studio boat. It is true that the artists may have touched up their paintings in the studio, but the awkwardness of nature and the truthfulness of tone was the aesthetic goal. Painting *en plein air* was a way of avoiding the formulae of the academic artists, and in spite of the difficulties of working away from the controlled environment of the studio, the rewards were prodigious – brilliant colour, a lack of conventional narrative and a sense of urgency.

Drawing after Monet's The Studio Boat, *c.1876. His floating studio enabled him to watch the light on the water.*

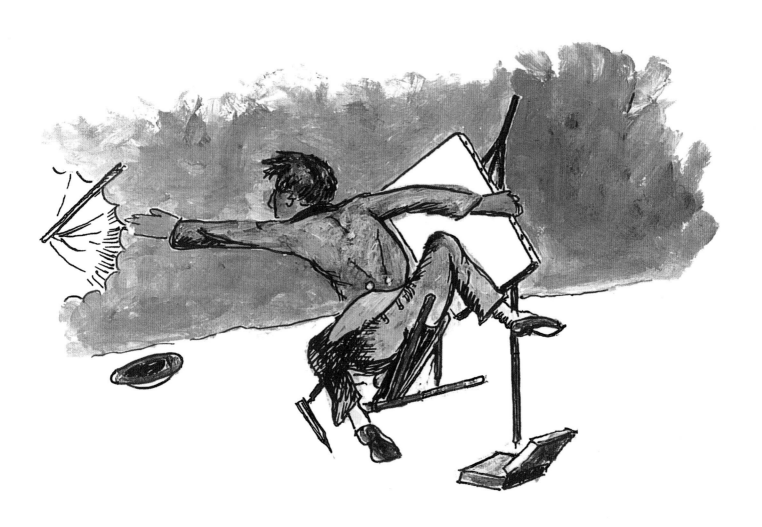

The difficulties of painting 'en plein air'.
Drawing adapted from the Pre-Raphaelite
painter, John Everett Millais.

Artists' colonies

To travel was considered to be the climax of the artists' training, and the ideal way was to win the prestigious Rome Prize, a scholarship to make the pilgrimage to Italy. Failing that, the alternative was to travel around your own country in search of a special light or new motifs. As soon as the annual Salon was over, artists left Paris to spend their summer sketching in oils in the countryside.

Monet, Renoir and Bazille were keen to gain experience of painting landscape, and headed in the direction of Barbizon, some fifty miles southeast of Paris. As described on page 55, the reason for choosing this location was that it already had a settled colony of artists, including the great Millet who lived there for twenty-seven years.

These Barbizon artists could give emotional support to the young rebels, and pass on their experience of painting *en plein air*. The area was attractive to artists because it offered a choice of scenery. Nearby was the forest of Fontainebleau, with its huge boulders and ancient trees; in the other direction was the flat plain of Chailly. Monet and his friends stayed in Chailly and Marlotte. Here they learned their first lessons in painting in changing light conditions.

The academic artist with an interest in the human figure worked in a studio, where the natural light was controlled by shutters and fabric blinds, but working out in the countryside – where the clouds continually moved – required a different approach that put huge demands on the artist's memory.

Although Barbizon painters Rousseau, Diaz and Troyon enjoyed the closeness to nature, they manipulated their compositions and the lighting effects back in the studio. Monet, Renoir and Bazille took painting *en plein air* a stage further by attempting to record exactly what they saw, even if this meant stopping and starting to follow the dictates of the weather.

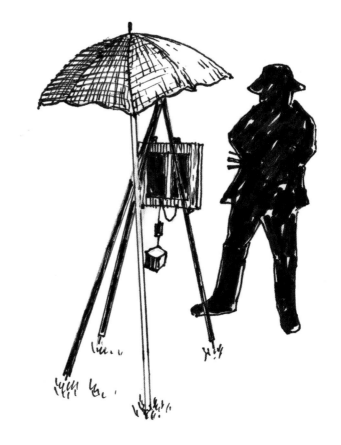

Monet's friend Camille Pissarro at work, from a lost painting by Ludovic Piette (c.1870).

Chiaroscuro to *peinture claire*

Landscape painters in the early nineteenth century constructed their paintings around the contrast of light and dark. The English painter John Constable referred to the 'chiaroscuro' of landscape. These painters imitated the effects of the open air by adding dark colours to their palette. The powerful contrast of white clouds and dark shadows was convincing enough, but when painters began to work outdoors, by habit they started to add white to their range of colours to emulate the piercing character of daylight.

The paintings of Constable have a distinct brown undertone compared with his near contemporary, the Barbizon artist Corot. One of the earliest painters to work *en plein air*, Corot adopted a cool palette lightened by the addition of white paint.

The use of white enables the painter to create pure colour contrasts by matching colours to the same tonal level. Blue, which is dark in its pure state, can be lightened to the level of yellow with measured amounts of white. This technique, known as *peinture claire*, gave the pre-Impressionists and the Impressionists themselves a useful tool with which to create paintings that suggested the luminosity of actual light.

Top: Grain stack painted in the chiaroscuro technique.
Bottom: Grain stack using pure colour contrast.

Impression: Sunrise

In 1873 Monet did not bother to submit any paintings to the Salon. Instead, he was working on a canvas that would eventually destroy the French establishment's showcase of painting and sculpture. His painting, *Impression: Sunrise*, was one of the stars of the first Impressionist Exhibition of 1874.

Although the word 'impression' had been used long before, by Manet and others, it was the title of this misty evocation of the port of Le Havre that attracted attention. Indeed, Leroy's criticism of the painting gave the movement its name (see page 71).

Painting from a window overlooking this maritime scene, Monet has integrated the realism of Courbet and Manet, both of whom painted the sea, with the exotic world of the Japanese print. Monet had recently returned from London where he and his friend Pissarro had admired the new display of paintings by English landscape painter J.M.W. Turner in the National Gallery. Turner's famous *Fighting Temeraire*, which shows one of Nelson's fleet being towed to the breaker's yard, balances a setting sun with a dark nautical buoy. Monet borrows this device by offsetting the orange sun with the silhouette of a black rowing boat.

Monet described his desire to paint the envelope of vapour that encircles a motif. Here the mist hangs over the harbour, uniting steam from the funnels and chimneys with clouds, and fusing the sky with the water. There are no details about the early morning sky, no information about the ships in the port and no explanation of what the small rowing boats are up to, because this is an impression. Nothing is explained, nothing is commented upon.

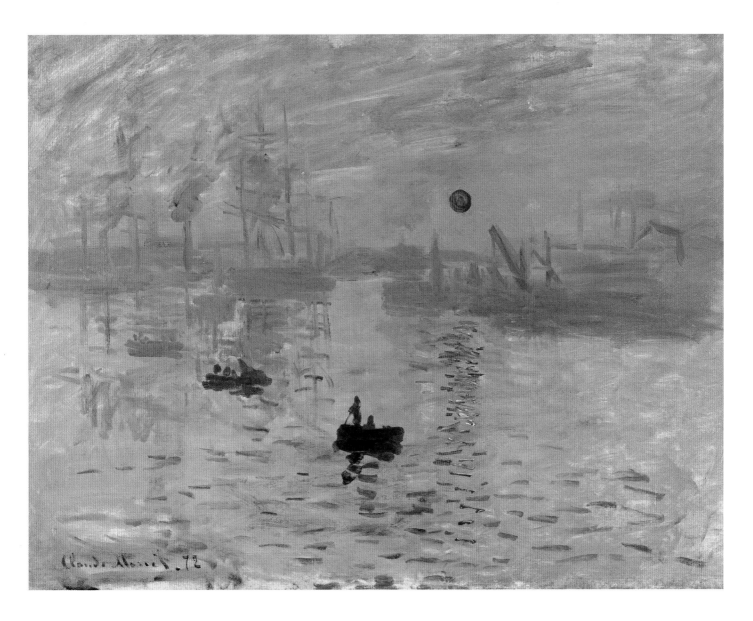

Impression: Sunrise *(1874).*
Musée Marmottan, Paris; Giraudon/ Bridgeman
Art Library

The first Impressionist exhibition

The idea of mounting an exhibition that was nothing to do with the official Salon had been planned by the Impressionists as early as 1867, but none of the friends had sufficient funds to implement their scheme.

In 1874, with Renoir as president of the Co-operative Company of Painters, Sculptors, Engravers etc. (Société anonyme cooperative d'artistes-peintres, sculpteurs etc.), savings were sufficient to organise an exhibition to be held in the recently vacated studios of the photographer Nadar in the fashionable Boulevard des Capucines. There were sixteen founding members – amongst them were Monet, Pissarro, Degas, Renoir, Sisley and Morisot.

Lasting a month, the entry to the exhibition was one franc, with a further charge for the catalogue. 3,500 visitors was an impressive number for an unofficial exhibition. The critics came to give their opinion, which was largely favourable. Monet exhibited *Impression: Sunrise*, a misty view of the harbour at Le Havre (see page 68), which gave its name to the movement.

He also exhibited the extraordinary *Boulevard des Capucines*, which drew

Drawing of Nadar's photographic studio in the Boulevard des Capucines, Paris. This was the location of the first Impressionist exhibition.

attention to the location of Nadar's studio, close to Garniers's Opera House at the centre of the rebuilt Paris. This painting, made from an upper window, showed Parisians wandering on the pavement, whilst on either side of the street horse-drawn cabs wait for customers. At the centre of the composition is a row of trees that divides the traffic from the pedestrians. This visually confusing but true-to-life record of a great city is a fusion of realism with the new emphasis on patterns of light that became recognised as Impressionism.

The critics

The name 'Impressionists' was coined by the art critic Louis Leroy, who reviewed the first exhibition for the newspaper *Le Charivari* under the heading 'The Exhibition of the Impressionists'. His article was composed as a comic dialogue between a crusty old artist and the young writer of the review. They stop in front of Monet's painting of the port of Le Havre: 'What does it depict; have a look at the catalogue,' asks the elderly painter. 'Impression: Sunrise' replies his companion. 'Impression ... a preliminary drawing for a wallpaper pattern is more highly finished than this seascape,' grunts the shocked academician.

The savage attacks are so memorable that they have obscured the fact that the critics were divided about the Impressionists debut. Some admired the paintings but not the subject matter, others were unhappy about the lack of finish. Here is a flavour of the reviews of the 1874 Exhibition: 'Monet has frenzied hands that work marvels' (*Le Siècle*); 'Might not Degas become a classic?' (*Le République Française*); 'This is Realism of the great school' (*L'Artiste*).

The second exhibition in 1876 attracted more thoughtless criticism: 'five or six lunatics, of whom one is a woman [Berthe Morisot], a group of unfortunates afflicted with the madness of ambition, have got together ... to exhibit their works' (*Le Figaro*).

The general opinion however was favourable, and Monet was warmly received: 'Monet's landscapes are very beautiful' (*L'Artiste*); 'Claude Monet, the dazzling colourist of the group' (*L'Echo*).

By the seventh exhibition, in 1882, Monet's reputation was sealed: 'the painter who put brush to these canvases is a great landscapist' (*l'Arte Moderne*).

A pregnant woman is dissuaded from seeing an exhibition of Impressionist paintings in case the experience damages the health of her unborn child. Drawing based on a contemporary cartoon.

The official Salon

When Monet was born, in 1840, there was only one venue to exhibit your works as an artist and that was the Salon (named after its first location in the Salon d'Apollon in the Louvre). By today's standards this annual exhibition was vast and indigestible, but as it had no competition the official Salon was an important date in the spring of each year. Private galleries and dealers were not much more than art suppliers or framemakers until the second half of the nineteenth century.

A jury system sieved through the entries that arrived at the exhibition halls on the Champs-Elysées, and the appointment of its members was usually a cause of fierce discussion. Those who sat on the jury had conservative tastes and could be relied upon to support the entries of their own students. In 1867 the writer Taine gave a sense of the taste of the jury – the subjects included Napoleon, undressed women and battle scenes. The preferred style was blandly photographic.

The system was tainted by favouritism and was designed to support those artists who painted history paintings in a polished manner, although landscape paintings were beginning to appear in quite considerable numbers. There was huge media interest in this Official Exhibition of Living Artists.

That the Impressionists decided to put on their own exhibition in the studios of the photographer Nadar demonstrates their collective courage. The general public visiting the Salon was guided by the prizes awarded to the exhibitors and the numerous purchases made by the State. Anyone who dared exhibit outside the system risked ridicule and poverty – clearly they were madmen with no talent.

A visit to the Salon. Notice how the pictures are hung frame to frame, and high up on the wall.

Honoré Daumier: Refusé,
from 'La Caricature',
15 March 1840. Cartoon of
an artist whose painting has
been refused by the Salon.
The Art Archive

EXERCISE:
Poppies at Argenteuil

Monet exhibited *Poppies at Argenteuil* at the first Impressionist exhibition of 1874. This famous painting of a summer's day demonstrates a significant change for this master of colour. *The Beach at Trouville* (page 27) is organised around the contrasting white highlight of Camille's costume and the black dress of the lady on the right. The poppy field is based on the opposition of the complementary red poppies and the green grass. Black is used sparingly to accent the foreground figure.

Poppies at Argenteuil *(1873). The Art Archive/ Musée d'Orsay, Paris/ Dagli Orti*

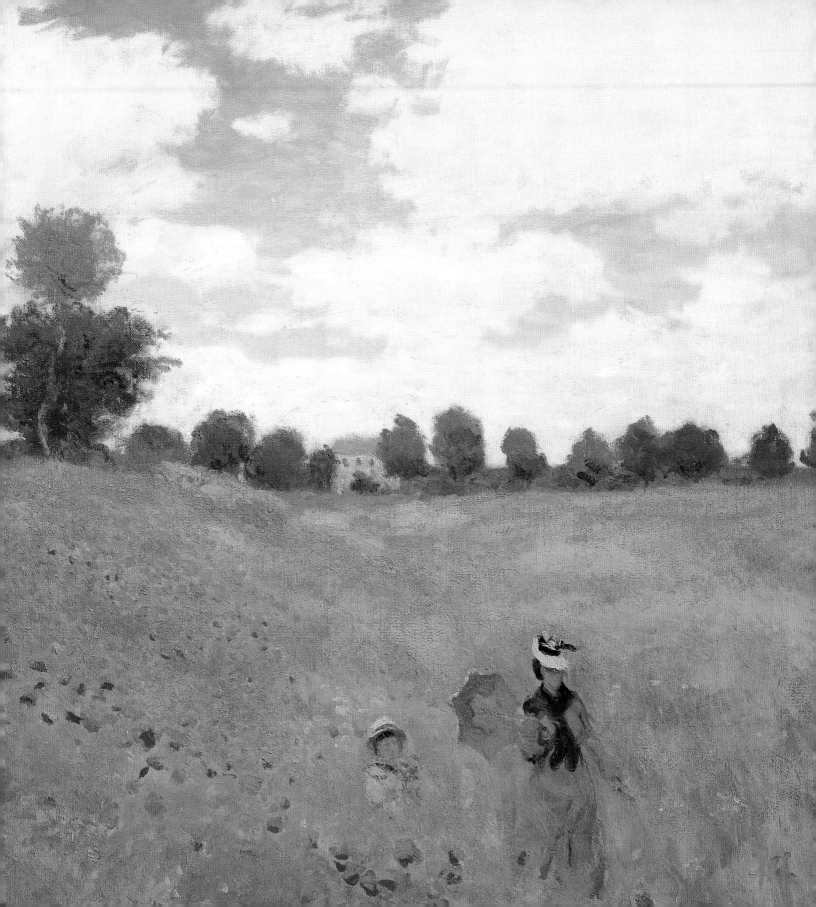

Understanding complementary colour

Colour contrast is at its most powerful when the two adjoining colours have the same tonal contrast.

By varying the purity of the two colours, different contrast can be created. With a limited palette the artist is able to 'stretch' the range of colours.

Top: The red square is easier to 'read' on the left-hand side. The right-hand diagram demonstrates colour contrast because the two colours are almost exactly the same tone.

Bottom: The red squares are the same hue but the surrounding colour changes. How does this affect the red square?

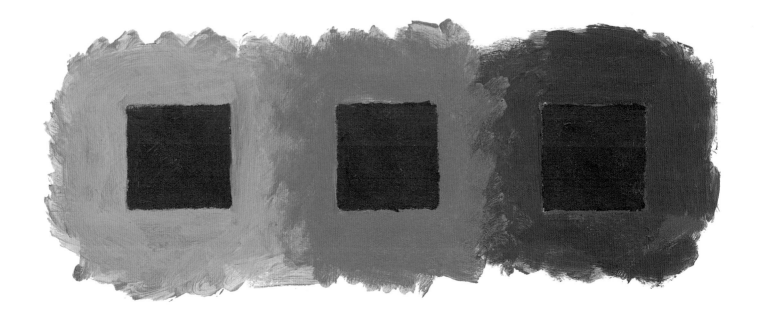

On the slightly off-white ground, Monet has mapped out the three basic tones of the landscape. The lightest tone will be the sky, next are those planes that lie on their back to face the sky and reflect the light, whilst the darkest are the vertical planes such as trees, houses and rocks.

Although different parts of the landscapes have their own local tone – some trees having darker foliage than their neighbours – this rule of three distinct areas of tone establishes a unity in the composition. The landscape painter must avoid nature's jumble of lights and darks. Every tone must know its place in the composition!

Fold a piece of paper as shown, and notice how the horizontal surface is lighter than the sloping plane.

STAGE 1: ESTABLISHING THE TONES

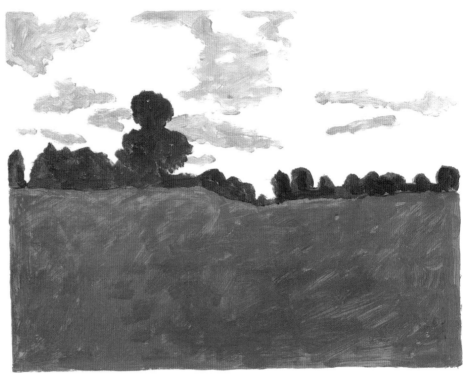

1. As Monet did, map out the three basic tones of the landscape. Over the pale ground, map out the patterns of the light blue patches of sky using Ultramarine mixed with White.

2. For the meadow, mix Ultramarine with Lemon Yellow and a touch of Vermilion to block in a mid tone. Lastly, shape the trees using a darker variation of the same colour mixture.

STAGE 2:
CREATING SPACE

1. Introduce a darker green (made of Ultramarine and Lemon Yellow) into the grass of the foreground to create variation of hue. Use vertical strokes to suggest the individual blades.

2. Gently brush clumps of yellow flowers across the background. Paint the clouds (White with a touch of Cadmium Yellow) into the blue sky holes.

3. At this stage, paint the little house, making sure the red roof is dulled down so that it follows the laws of aerial perspective. Add a little pale blue to the orange red to create this effect.

4. Give the meadow a scumble (see opposite) in the middle distance. A dryish pale colour is scuffed over a dark colour, resulting in a bluish effect.

5. At this point, rough in the two sets of figures.

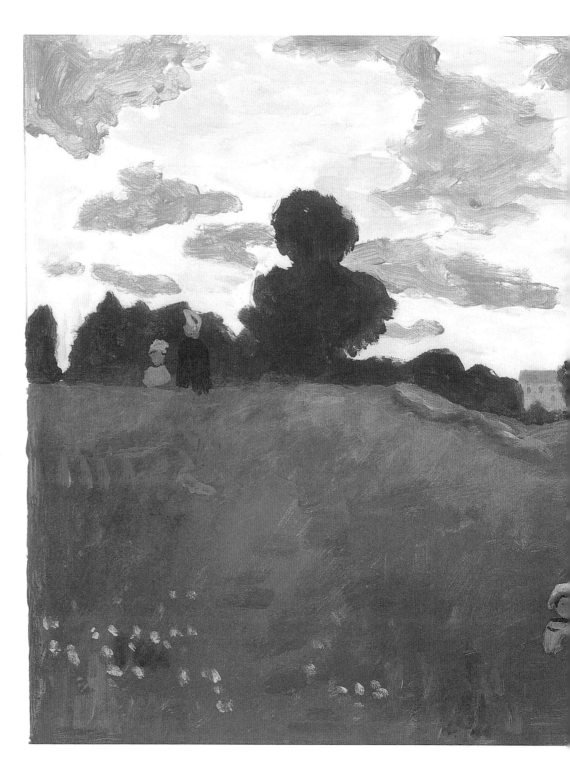

In a scumble, a lighter colour is scuffed over a darker base colour. The scumble will appear slightly cool.

STAGE 3: THE POPPIES

This detail shows how Monet dabs splodges of red paint and then makes the centre darker with brushmarks of a deeper colour.

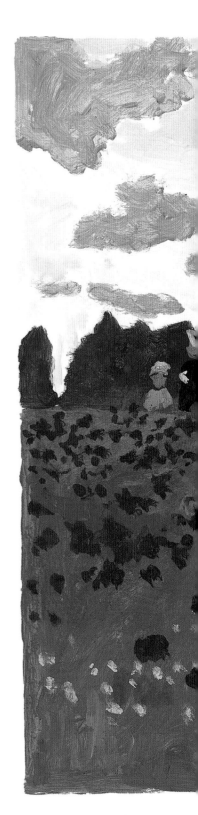

1. Dab the poppies across the meadow with a paler shade of Vermilion.

2. Re-touch the centres of the poppies with spots of pure vermilion. Now your picture should come to life.

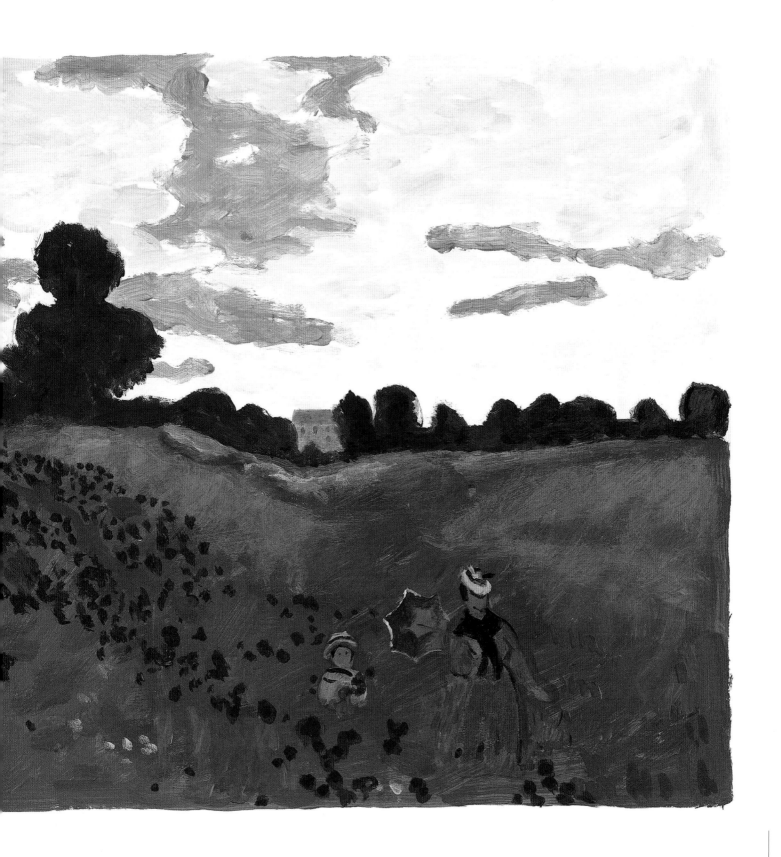

Contrasting red and green

Red and green are complementary colours. Even before the colour theories of the seventeenth century, artists understood that their greens could be enlivened by splashes of red.

The aim of this project is to demonstrate how an area of green – in this case a salad bowl of lettuce leaves – can be made to seem more appetising by the addition of some tomatoes. The question is how many tomatoes do you need before there is a balance between the two colours? Books on colour use the technical phrase, the 'contrast of extension', to describe the relationship between areas of colour. The red could also be red peppers, beetroot, radishes or even the more orangey carrot.

Top: Sketch of a green salad.
Bottom: The same sketch, enlivened
by the addition of red tomatoes.

Success – and loss

Settled in Argenteuil after the Franco-Prussian war, Monet enjoyed a decade of stability. True, there was never enough money to support his bourgeois lifestyle, but the paintings of this period celebrate domesticity. Camille, recognisable by her parasol, wanders across fields, saunters by the riverbank or sits reading under a tree. Baby Jean is never far away.

In the delightful pastorals of this period, Monet updates the poetic landscapes of earlier French painters such as Claude, Watteau and Boucher. But his idyllic settings are not removed from 'modernity' – shepherds give way to promenaders, cast iron bridges replace classical temples and light is recorded with unsentimental accuracy. However arcadian some of these landscapes may seem, there is always a reminder that Paris is only 15 minutes away by train. Whilst yachts tack and come round on the river, above them locomotives steam across ugly railway bridges, a goods train trails smoke across the valley of the Seine and engine sheds are depicted as lovingly as any group of poplar trees.

Monet frequently travelled up to Paris to help organise the exhibition of 1874. The subsequent auction of his paintings and others by Morisot, Renoir and Sisley was unsuccessful.

By 1877 he was spending less time *en plein air* around Argenteuil, leaving the fields behind for the end of the line in Paris. The series painted in the Gare St Lazare were the culmination of his fascination with that most conspicuous symbol of modernism, the railway. This decade ended with the move to Vetheuil, and the death of Camille.

Monet lost his favourite model in September 1879. In the many portraits of his first wife, sometimes reading, seated on a garden bench, enjoying the beach or even dressed up in a Japanese costume, Camille has a delicate, fragile beauty. She died after a long illness, worn out by the birth of her son Michel and the difficult life supporting an impoverished artist. Only a month before she died Monet was writing to a friend to explain that the family was without funds and he was unable to relieve Camille's suffering through lack of money.

The many affectionate pictures of Camille and the young Jean Monet suggest contented domesticity and yet, as his wife lay dying, Monet found himself analysing the colours of her deathly complexion. At her bedside the grieving husband and the enquiring artist were at odds – he nevertheless went on to make a final portrait as she lay wrapped in a shroud, with flowers laid across her body. It was this shocking detachment that enabled Monet to investigate the natural world with such scientific accuracy.

Drawing of baby Jean asleep, from a painting by Monet.

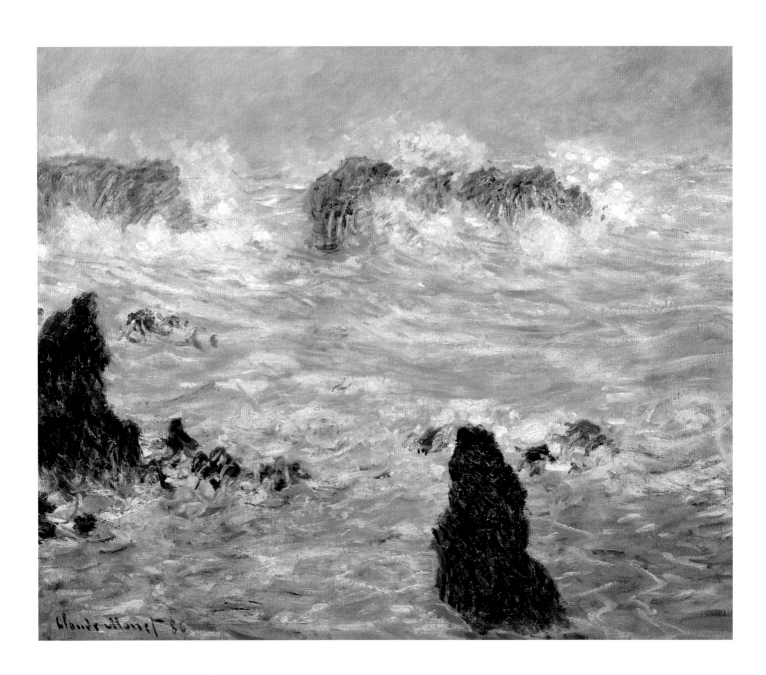

How Monet subverted a traditional subject

Many of the locations on the Normandy coast that had excited Monet in the past, such as Honfleur, Trouville and Varengeville, were quickly becoming popular holiday destinations, made fashionable by the artists who discovered these picturesque spots. Looking for nature in the raw, Monet travelled in 1886 to the rugged Belle-Isle, off the coast of Brittany.

Monet wrote to his friend, the painter Gustave Caillebotte, that since he was used to painting the English Channel, the Atlantic Ocean was a new challenge. On the island, he set out in all weathers – on one occasion in a hailstorm, on another, equipped with ropes to prevent gusts of wind blowing away his easel – but always with a bundle of canvases. He changed over his supports as the weather changed its moods.

By this stage in his career he had dispensed with black, and was using the palette listed on page 21.

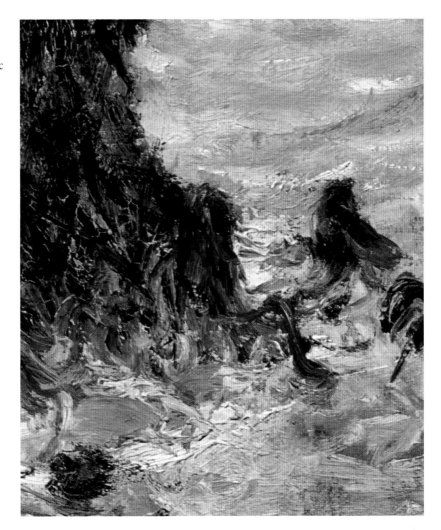

Storm Off the Belle-Isle Coast (1886). The Art Archive/ Musee d'Orsay, Paris/ Dagli Orti

EXERCISE:
Storm Off the Belle-Isle Coast

In the thirty-nine 'Belle-Isle' paintings, Monet used round brushes with long bristles. Short bristle brushes push the oil paint across the canvas rather like a bulldozer. When several layers have been built up, paint is laid on with the longer bristle to prevent disturbing the under painting. It is important not to dab too hard at the surface. Instead, gently stroke the colours across the still-wet paint film.

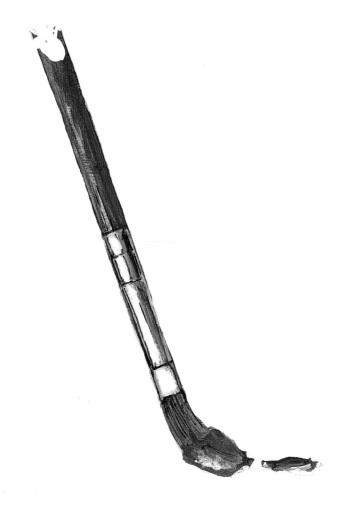

It should be noted that colours dry at different speeds. Slow driers on Monet's palette were Emerald Green, Cadmium Yellow and Vermilion. Their drying time can be accelerated by mixing with Lead White, which was part of the technique of *peinture claire* (see page 67).

In this storm scene, Monet may have recalled the paintings of Turner (whose pictures of the sea he encountered in 1870, when he and Camille Pissarro were living in London and visited the National Gallery). Turner expressed the moods of the sea by manipulating the horizon; sometimes it is high up as the waves threaten, whilst on a calm day the sky dominates. Here Monet has certainly taken notice of Turner's breaking up of the horizon line to express the sublime power of the elements.

The short bristle brush is used for the earlier layers of the painting.

STAGE 1: THE ROCKS

1. Mix together Ultramarine and Alizarin into two areas on your palette. One will be biased towards red and the other blue. Monet found colour where others only saw grey.

2. Build up the 'grey' rocks with diagonal brushstrokes of the two mixtures. Make your rocks larger than their obvious outlines, especially at the base because the white foam will overlap them.

STAGE 2: VARYING THE BRUSHSTROKES

1. Using Ultramarine and White, paint in the sky using brush marks that lean in the opposite direction.

2. Now, with a combination of Ultramarine, Cadmium Yellow and White, paint long looping strokes for the waves.

Brush marks

Of all the components of the 'Impressionist' revolution – new pigments, up-to-date equipment, new theories of colour – none was more important than the 'tache' or brush mark.

A century before, the French painter Jacques-Louis David had advised that brush marks should not be displayed, because it was the painted form that mattered. By the time Monet was working on Belle-Isle, his repertoire of clearly visible brushstrokes was extensive, and his contemporaries were also experimenting with different approaches. Georges Seurat was engaged in developing Pointillism, using tiny spots of colour, and Gauguin was unifying his Brittany pictures with all-over vertical brush marks.

Monet's painting expresses, above all, movement. The rocks push themselves upwards through the stormy sea, with the diagonal touches of the sky revealing the direction of the gale.

Diagonal brushmarks for the sky; vertical marks for the rocks; sweeping horizontal lines to suggest the fury of the storm.

STAGE 3: FINAL TOUCHES

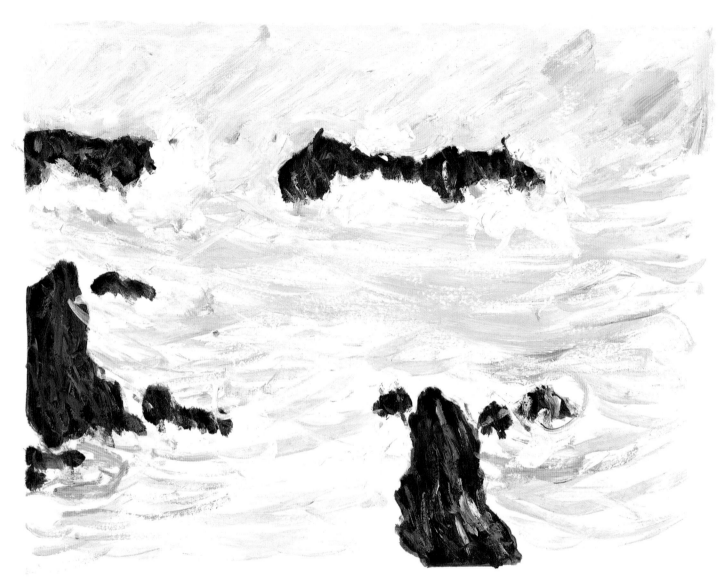

1. The rocks are reinforced with touches of Vermilion, Ultramarine and Cadmium Yellow in mixture.

2. The sea is built up with more looping strokes.

3. Pure White is dabbed on for the foam. Note how the foam marks the moment when the right to left current explodes against the standing rocks.

Painting swirling waters

The study of shipwrecks in pictures is fascinating. During the early years of the nineteenth century, the taste for storm paintings resulted in some of the English artist J. M.W. Turner's most exciting works.

Describing the energy of the sea is not easy. It is the swirling foam and direction of the current that is difficult, so turn on the tap of the sink or the bath and try to capture the force with which the water issues from the faucet.

The pattern of tones, the lights and darks, are different from the reflections on page 59. The white highlights offer little contrast to the body of the water.

The highlights are painted as broken lines to suggest the moving water. Bath foam added to the water gives another useful effect to try and sketch.

Bath taps filling the bath makes good practise for painting foaming water.

Travels and architecture

Architecture seems an unlikely subject for an Impressionist painter, and it would be impossible to use Monet's paintings of Rouen Cathedral or the Venetian palaces as a blueprint for construction. There is little detail and a general fuzziness that is diametrically opposed to the architect's measured plan and elevation.

Yet Monet delighted in painting structures such as the bridges over the rivers Seine and Thames, a humble customs house at Varengeville, the station shed of the Gare St Lazare, or the elegant Hotel des Roches-Noires at Trouville. He may have played down the sometimes self-important details of man-made structures, but he emphasised the architectural power of natural forms, a row of poplar trees, the bulk of a grain stack, the rocks of Belle-Isle. In this he owes a debt to the seventeenth-century Claude Lorraine, who cared little about drawing the construction of a building but more about the way it reflected the light.

Nor does Monet distinguish between great architecture and the vernacular. His art does not explain or educate, it presents us with a fleeting moment of light in all its dazzling character. We may not know the street, or recognise the building, but we are always aware of the weather conditions!

Monet in Venice

Intended as a break from the intensely focused sequence of the water lilies, Monet visited Venice in 1908. In fact, it was far from a rest cure. In two months he produced thirty-nine paintings. To such a painterly artist, Venice was an important centre of pilgrimage. In the churches and the Academia gallery Monet could marvel at the ancestors of Impressionism – Giorgione, Titian, Veronese and Tiepolo – and visit the locations painted by Turner and those drawn by his friend Whistler.

The city's distinctive atmosphere created a school of painting which argued that truth

Below left: A pearl painted in a linear style.
Below right: The same pearl painted in a painterly style (after a detail in Veronese's The Family of Darius before Alexander, *c.1570, National Gallery, London).*

to nature begins with accurate rendering of colour and light. Monet would surely have been impressed by Titian's method of building up his paintings with patches of bright colour rather than following drawn outlines.

Veronese's painterly detail (see opposite) was picked out by the nineteenth-century art critic John Ruskin as having a specially Venetian quality. Ruskin did a great deal to popularise the art and architecture of Venice with his massive publication, *Stones of Venice*, revised as a tourists' edition in 1877. The illustration here of the windows of a Venetian palazzo is reproduced from the original three-volume edition.

Engraving of a Venetian window, from Ruskin's The Stones of Venice *(1851-53).*

EXERCISE:
The Palazzo da Mula

Monet did take a few canvases with him to paint 'souvenirs' of Venice, but once he was there he regretted having left it so late in his life to capture the distinctive atmosphere of this watery city.

The main attraction of Venice for artists is the quality of the light, altered by the seasons and the tide, as well as the flickering reflections bouncing off the buildings that line the canals.

Amongst the thirty-nine paintings from Monet's trip to Venice are two versions of the fifteenth-century palace, the Palazzo da Mula, on the Grand Canal.

Drawing of the Palazzo da Mula, showing the whole building.

The Palazzo da Mula *(1908). The Art Archive/
National Gallery of Art, Washington D.C./
Joseph Martin*

Always the radical, Monet rarely adopted the accepted system for making a painting, but in this case the building had to be roughed in before the water could be considered in any detail. Nevertheless, Monet must have had a clear idea of his colour range. The blue shadows and greenish water are off-set by hints of red. This system uses pairs of complementaries.

These are made up of one primary colour (say, red) and a mixture of the remaining primaries. Thus blue and yellow mix to make green, which is the complementary to red.

Complementary colours are the painters' secret weapon. In the past it was not always easy to find a bright green, but by juxtaposing a dull green with its complementary colour – red – it could be made to seem vivid. Pairing of orange and blue was used a great deal by the Impressionists, whilst purple and yellow was a favourite combination of Van Gogh.

To test for true complementaries, mix them together to make a dark 'mud' and then add white. If they are truly complementary, the result will be grey.

The complementaries of green and red, orange and blue. In the Palazzo da Mula *Monet opposes the blue against a small quantity of orange, and the greenish water is set off with tiny points of red.*

STAGE 1: THE BUILDING

This painting uses the palette on page 21, but where to start? The two gondolas break the vertical/ horizontal grid, so begin with the boats and the dark arches above them. Relate all the other features to this starting point, by lining up the windows and reflection to this focal point.

1. Begin by using dilute Ultramarine to indicate the Gothic windows and the lower square apertures.

2. Reinforce these shapes with pure Ultramarine.

STAGE 2: CREATING COLOUR BALANCE

Notice the difference in size between the 'field' of blue and the touches of pinkish orange. The German poet Goethe spent twenty years investigating colour. He demonstrated that colours of the same shape, size and intensity do not balance. For instance, only a small amount of yellow is needed to equalise a greater measure of purple. Because orange is lighter than blue, there must be a larger area of Ultramarine to be visually equal.

1. With a round brush, introduce hints of pink and orange into the picture. These enliven the cool colours that dominate this picture. A painting made entirely of greens and blues will lack interest unless there is a hint of warmth, as in this picture. Then work up the stuccoed walls of the palace.

2. Indicate the main reflections in Ultramarine. They should be devolved at this stage.

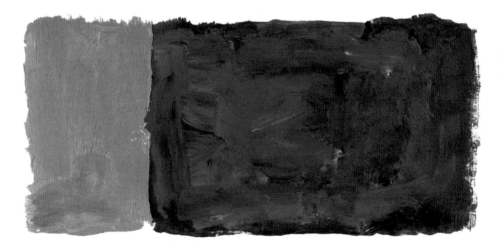

Diagram showing the contrast of extension between orange and blue. To achieve a balance between the two pure hues, the proportion must be adjusted.

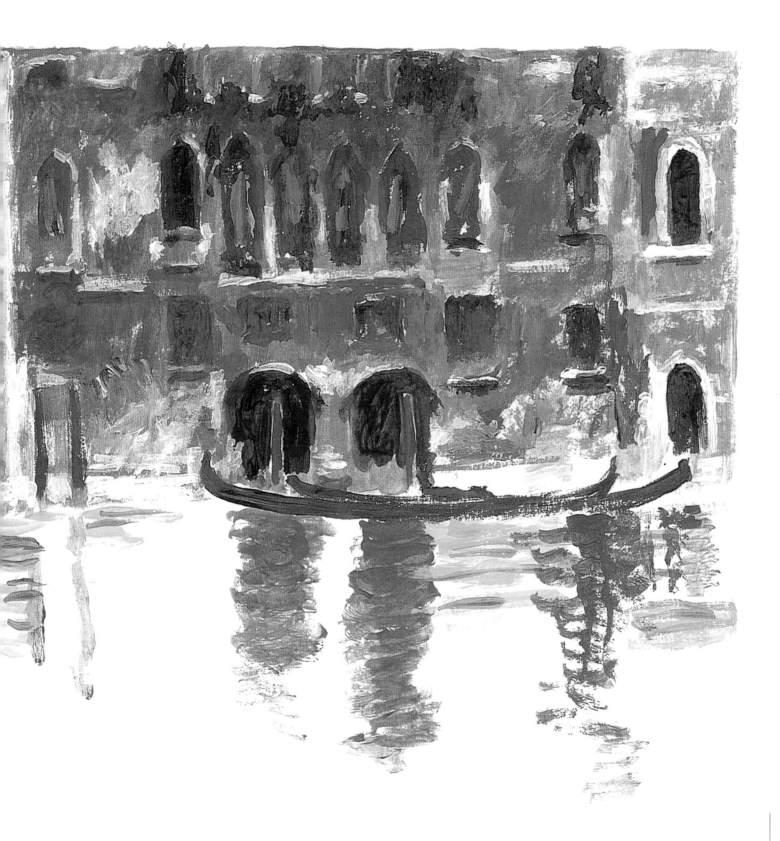

STAGE 3: THE WATER

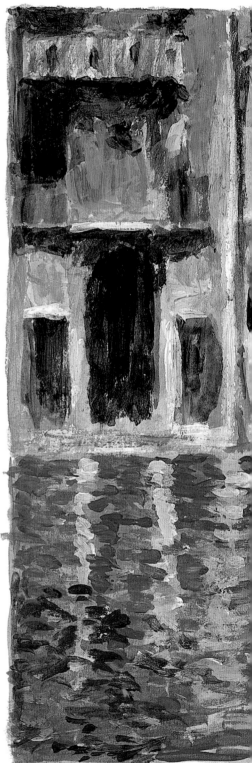

Diagram of the green/blue ratio which approximates to Goethe's system.

1. Brush a dilute Emerald Green across the whole of the water once it has dried to the touch. This layer should be thin enough to see the reflections that you have already painted.

2. With a small brush, work over the water, reinforcing the reflections and building a pinkish network at the bottom left.

Now that the picture is complete, notice the proportion of greenish water to the bluish Palazzo. This fits Geothe's ratio of four units of green to six of blue.

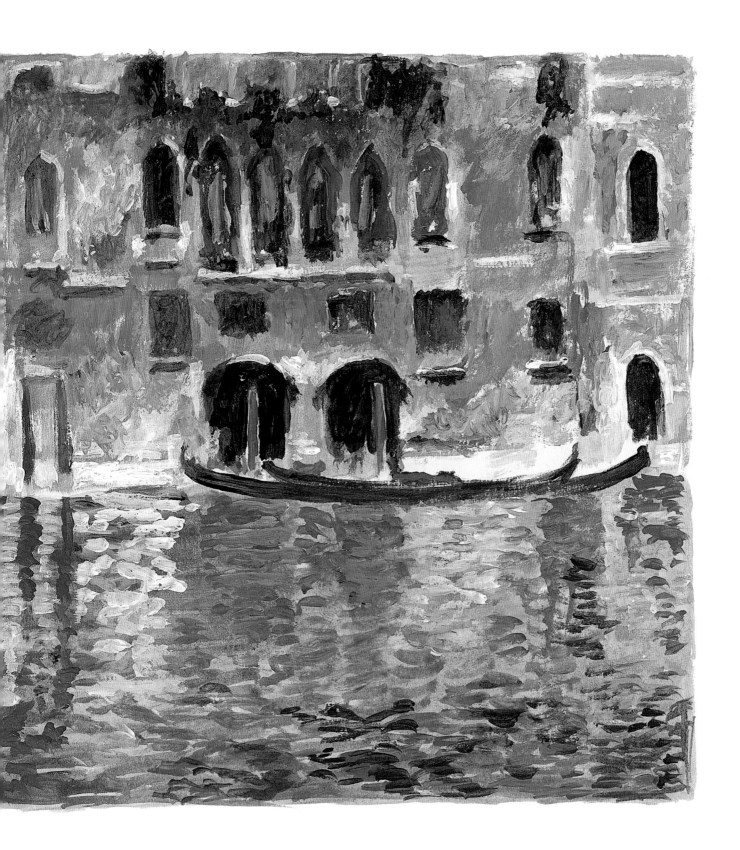

What you might do with a bookcase

Monet was not an architectural draughtsman. His buildings are not delineated by outlines but built with softly edged blocks of colour.

You may not have a building of character to practise on, so try working with books on shelves. Lay down a blue across your canvas or oil-painting paper. Without drawing out the composition, block in the shapes of the books. Note the shapes of the gaps between the objects – these are the so-called negative spaces.

The bookcase is painted as though it were a piece of architecture. It is loosely painted, without any preliminary pencil drawing. The outlines of the books were adjusted by repainting the background colour.

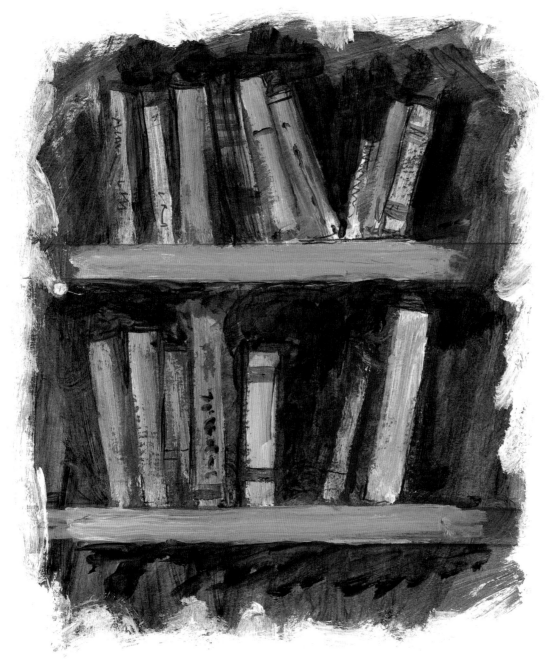

Monet's later life and the break-up of the group

It was inevitable that the Impressionist group would gradually disintegrate. On a social level, the politics of the anarchist Pissarro and the ultra-conservative Degas caused friction. Then, in 1880, Monet and Renoir began to submit paintings to the despised Salon.

Monet had one painting accepted and one refused, and in the same year he decided not to take part in the fifth Impressionist exhibition. At this time Renoir began to reject the visual language of Impressionism, preferring a more hard-edged style inspired by Italian art. Only Monet and Sisley remained true to the original principles.

Just before the death of Camille from tuberculosis, the Monet family had joined forces with the Hoschede family and settled in Vetheuil, another village on the banks of the Seine. Monet's erstwhile patron Ernest Hoschede had been declared bankrupt and had fled to Belgium. On his death in 1892, Alice Hoschede married Monet.

In 1881 and 1882 the dealer Paul Durand-Ruel regularly purchased Monet's paintings and even organised the seventh exhibition. In the next year the two families moved from Vetheuil to Poissy and finally, sending their belongings in boats downriver, they moved to Giverny where they rented the now famous farmhouse.

In 1886, the last Impressionist exhibition took place above a fashionable restaurant in the Rue Lafitte. Monet did not exhibit. Degas was very much in evidence, as were the painters we now know as Post Impressionists – Gauguin, Seurat, Signac and the Symbolist Odilon Redon. Monet was busy painting on Belle-Isle, in Antibes in the Midi and later in the Massif Central.

After a retrospective at Georges Petit's gallery in Paris, Monet began working on his grain stack series and had sufficient funds to buy the house at Giverny. After ten years of domestic upheaval Monet finally settled in Giverny. Here he continued to declare his faith in Impressionism with the remarkable sequences of his beloved pond with its water lilies overhung with weeping willows.

View of the garden path at Giverny, leading away from the house.

Monet and Turner

When the great English landscape painter J.M.W. Turner died in 1851, some 19,000 works on paper and several hundred oil paintings were willed to the nation. A selection of the oil paintings was displayed in London's National Gallery. Monet and his friend Camille Pissarro, having fled to the safety of London in the winter of 1870, visited the National Gallery and both admired Turner.

This copy of a Turner watercolour shows how the English artist shared Monet's fascination with light and water.

Monet and Turner were fascinated by water – Monet had a floating studio, and Turner was rowed up the River Thames whilst he sketched. Both painted Venice. Both painted the façade of Rouen cathedral – but there was one subject that lodged in Monet's consciousness and that was Turner's *Rain, Steam and Speed* of 1844. This canvas shows a railway train rushing across a bridge over the River Thames at 43 miles an hour! On the river bank indistinct figures wave at the train.

In 1877 Monet was inspired to paint a series of pictures devoted to the railway, but there was a difference. Turner's visual vocabulary included symbolism, with a hare racing down the track ahead of the steam engine. Monet had no time for this type of language, he painted a train that only symbolised modernism. He was not interested in speed, but in the clouds of smoke pouring from the engines as they stood in the terminus of the Gare du Nord.

Pissarro also provided evidence of Turner's influence in his *Lordship Lane Station*, where a train halts in the suburbs of South London. However, when an English art critic suggested that the Impressionists were merely following in the footsteps of Turner, Pissarro was furious and pointed out the essential difference between the English artist and the Impressionists. For Turner, shadows were merely an 'absence of light', whereas the Impressionists were famous for their recording of coloured shadows.

Monet and London

Monet was fond of London. The city was particularly attractive to French artists because the Royal Academy, being a private charity, was not funded by the State. There was a feeling that the art establishment in England was more relaxed than the ultra-conservative Academie across the channel.

Monet also hoped to sell his paintings of the Thames and of Hyde Park, but the visit was not a great financial success. Ironically, it was a meeting with the French art dealer Paul Durand-Ruel that led to his work being shown in London's New Bond Street, and the beginning of a long-term relationship with one of the most important supporters of the Impressionists.

In 1899, 1900 and 1901 Monet returned to London as a wealthy man, concentrating on motifs that could be viewed from his room in the Savoy Hotel as well as painting the Houses of Parliament from St Thomas's Hospital on the opposite side of the Thames. He recorded that he had up to a hundred canvases on the go for a single subject. In a comforting note, the great painter described that when the light changed he would check through his store of half-completed pictures to find one that was near the prevailing conditions. He admitted that he always managed to overlook the one that was closest to what he wanted!

The later London canvases reveal Monet's real interest in London – the fogs. He could not understand the desire of English painters to paint every brick, when the smog fused bridges with their reflections, fused smoking chimneys with swirling mists, and fused moving currents with the dense sky. Monet's London paintings give the River Thames a prismatic character, enabling him to modulate between cool shadows and warm sunlight. They were a triumph of pure colour contrast.

Drawing showing corner of the Turner display in the National Gallery at the time of Monet's first visit to London.

EXERCISE:
The Houses of Parliament

Barry and Pugin's neo-Gothic parliament building seems an odd
subject for an artist who turned his back on the tourist sites of the
great cities. Monet preferred the Gare St Lazare to the Eiffel Tower,
the crowded Boulevard des Capucines to Notre Dame, but the London
Houses of Parliament followed in the footsteps of a genuine Gothic
building, Rouen Cathedral.

Built between 1836 and 1868, the Houses
of Parliament was built in the English
Gothic Revival style, with Pugin assisting
on the Gothic detailing. The medieval
gothic style continued to interest artists
and architects throughout the nineteenth
century. Monet's friend, the sculptor Auguste
Rodin, wrote a book on the French Gothic
cathedral. Monet may well have been
amused by the use of this style for the
British Parliament. It was selected on
grounds of nationalism, as it was associated
with English medieval architecture. The
French knew better, for its birthplace was
St Denis on the edge of Paris.

 In his paintings of the Houses of
Parliament, Monet combined the Gothic
architecture with the water that he seemed
to crave. He set up his easel in St Thomas's
Hospital on the far bank of the Thames,
and started on a new series that pushed his
coloured 'envelope' to new heights.

 Monet worked on a series of these
Parliament canvases, then transported
them back to Giverny where he continued
to work them up. This is one of the most
difficult of the works in this book to
reproduce, on account of its subtlety.

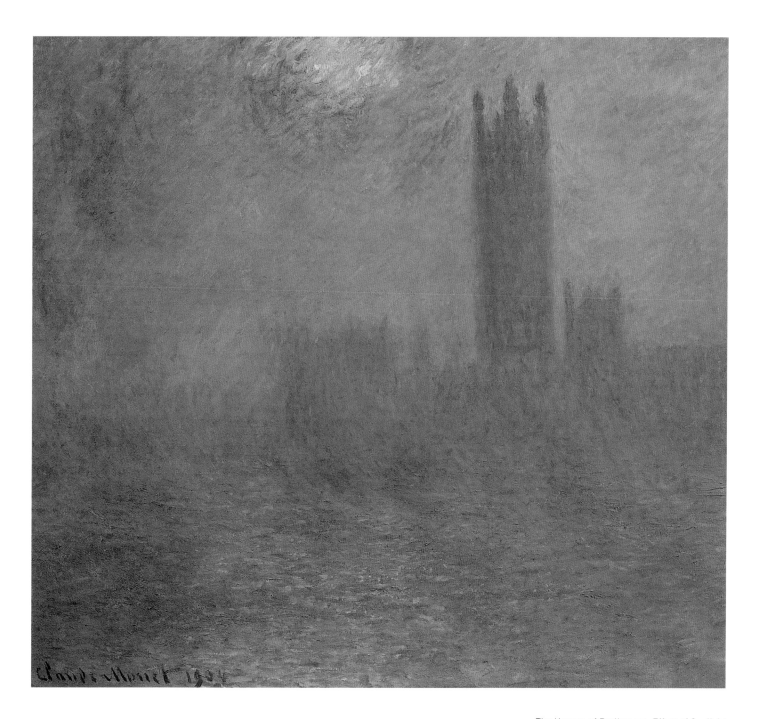

The Houses of Parliament: Effect of Sunlight
in the Fog *(1904). The Art Archive/ Musée d'Orsay,
Paris/ Dagli Orti*

STAGE 1: PLACING THE BUILDINGS

How do painters think? What is meant by 'visually literate'? Of course artists think about the motif, but the moment it is decided what to paint other factors come into play. It is easier to consider these decisions in terms of contrasts – between light and dark, between pure colours and neutral tones, or a contrast between warm and cool colours. This latter opposition was the fundamental rule of Impressionist painting.

The English landscape painter John Constable referred to the chiaroscuro of nature. If Monet and Pissarro admired his work, they substituted pure colour contrast for his patterns of light and dark. The warm and cool contrast becomes very evident in the Houses of Parliament series if the paintings are reproduced in black and white – the whole picture appears to be grey.

1. On the off-white canvas, establish the lines of the Victoria Tower and the main bulk of the Houses of Parliament. Notice how the tower lies two-thirds across the width of the canvas.

2. Follow the upright direction of the tower with your brush marks.

Top right: Monet began his career using strong contrasts of light and dark.
Bottom right: The contrast of warm and cool does the same work of chiaroscuro but emphasises the colour contrast.

STAGE 2: PAINTING
THE ELEMENTS

1. Develop the sky, using horizontal strokes, which are repeated in the river.

2. Introduce yellow into the centre of the pinkish central section of the sky.

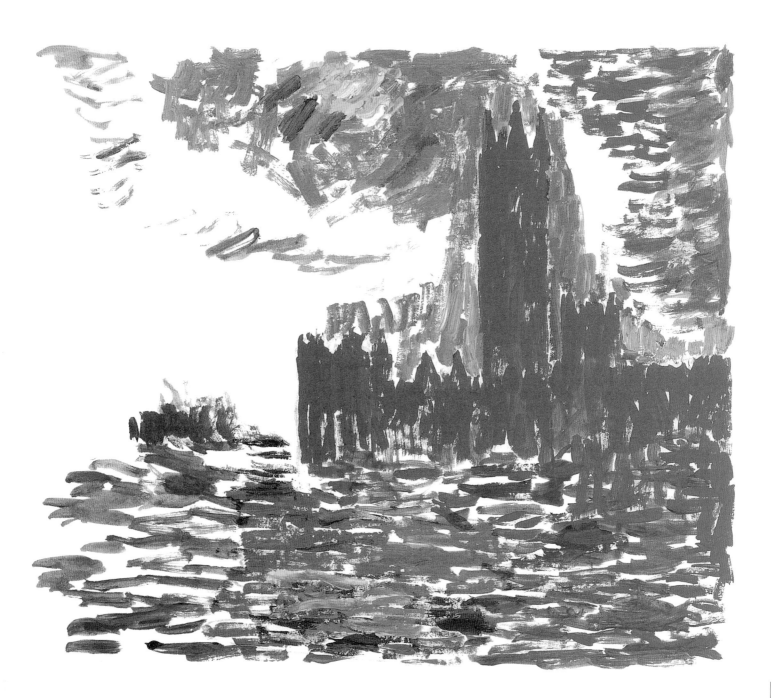

STAGE 3: THE BLENDING

This painting is one of the least diagramatic of Monet's paintings. A diagram such as you might find in a text book uses black lines for clarity. Here Monet fuses colours into a continuous haze. The blending of the orange/yellow with the blue sky and water will be a challenge!

1. Allow the hot and cold sections to dry before starting to blend the colours.

2. To blend the colours into each other, merge the horizontal strokes into the vertical marks of the building.

3. Use the wet in wet technique to mix blue and orange to a greyish sludge.

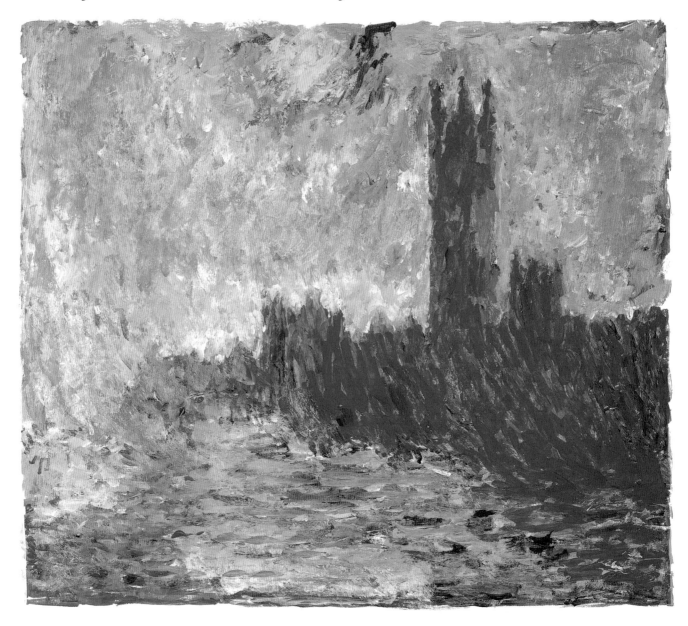

Blending colours

Take a bunch of flowers, and pick out a dark red bloom as well as a pink one. Paint them as you see them in their true colours. Then cover the canvas with blue but whilst it is still wet work in some red in order to unite the two flowers to the cool background. The red becomes the connecting colour between the pale pink and the purple.

Flowers with a background that modulates between the colours of the two blooms.

Narrative painting before Monet

The dramatic interaction between the individuals in Titian's paintings set a standard for narrative painting in succeeding centuries. The academic training of French artists recognised the importance of studying the great masters in the Louvre to gain a better understanding of how to construct a narrative. The histories of Plutarch, the poems of Ovid and Boccaccio and the Bible were searched for stories that would effectively translate into a visual form.

In 1766 the German critic Gotthold Lessing published his *Laokoon*, a comparison between the arts of poetry, sculpture and painting. 'The pictorial narratives of painting and sculpture', he wrote, 'are only effective if the artist is able to select the correct moment in the story. This 'critical' moment should give some indication of what has happened and what is about to happen'.

For French artists in the middle of the nineteenth century, originality lay not in unusual colour schemes or expressive drawing but the effective selection of the 'critical' moment.

Landscape paintings, where the emphasis was less on human activity, had other concerns. Their narrative was the changing seasons, the growth of a tree, or the geological history of a mountain. A tree may be drawn and painted as it grew, so that the painter's brush mimics the growth of the actual tree by following the path of the branches. This is the lesson that Monet learnt from the painters of the Barbizon school.

Monet's series paintings take narrative in a new direction, anticipating the medium of film. He presents the same subject – Rouen cathedral, a row of poplar trees or grain stacks – at different times of the day with changing effects of light. The artist is not concerned with the building, the trees or the piles of harvested field crops, but the ever-changing atmospheric envelope around these 'subjects'.

Once considered to be a highpoint of narrative art, the Laocoon is a first-century sculpture, now in the Vatican. The subject is from the story of Troy. (The high priest Laocoon warned that the wooden horse of the Greeks was dangerous. The gods supporting the Greek cause sent sea serpents to strangle him and his two sons.) This was a sculpture much admired by academic artists, but not by Monet.

The series paintings

Painters from the Renaissance onwards had grappled with a conundrum. Painting was a static object, but how could the artist represent movement? Titian and the Baroque artists had triumphed over their limitations, but the early nineteenth-century neo-classical artists, such as Jacques-Louis David, stopped their figures in their tracks. Antique sculpture was their inspiration, and remained so until the second half of the nineteenth century.

What Monet achieved was a fusion of the two aspirations, for his subjects were always static but the light in the paintings and the brush marks on the picture plane seemed to move. In his earlier years he moved around the length of Europe searching for motifs, but in his later years he reversed the procedure – he found a motif and let the light move across it.

The series paintings (of the grain stacks, poplars, Rouen Cathedral and Waterloo Bridge) were also designed to meet the challenge of the Post-Impressionists, who were about to steal the initiative away from the only painter who still waved the flag of Impressionism. Seurat introduced a scientific method of painting with tiny spots of colour, and Gauguin was developing a type of symbolism that seemed to be in tune with fin-de-siècle France. The answer was a filmic sequence that featured light itself.

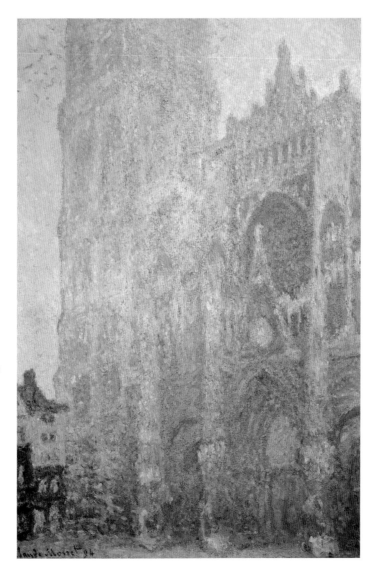

Rouen Cathedral. Facade and Tour Albane (Morning Effect), *1892-94. The Art Archive/ Musée d'Orsay, Paris/ Dagli Orti*

Monet's narrative of light

In a building opposite the Nadar's studio, where the Impressionists held their first exhibition in 1874, the Lumière brothers presented the first public showing of the Cinématographe. Many paintings by the group who also first exhibited in the Boulevard des Capucines appear to anticipate the camera angles of the newly invented cinema.

Examples of this anticipation of camera angles include Degas's paintings of circus acrobats seen from below, women bent over drying themselves after a bath, or race horses in action.

Monet took a different direction, by holding his camera angle on one subject whilst the light changed. He complained in a letter about the difficulty of this approach, because the sun sets too quickly. His series paintings of Rouen cathedral were brought back to Giverny where he could exhibit them as a sequence – *Rouen Cathedral (Morning Effect)*, *Rouen Cathedral (Grey Day)* or *Rouen Cathedral (Sunset)*.

Two ladies with amazing hats watch a Lumière brothers film. Drawing after a poster by Abel Truchet.

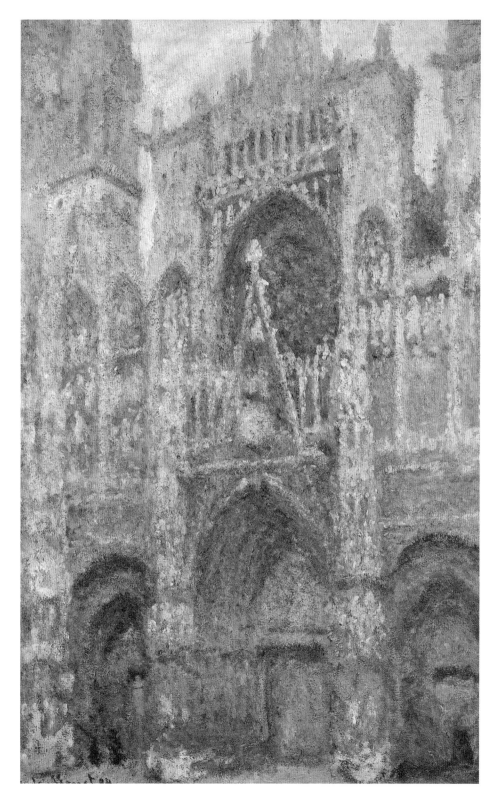

Rouen Cathedral Facade (Grey Day),
1892-94. The Art Archive/ Musée d'Orsay, Paris/
Dagli Orti

How the series paintings were painted

It has been suggested that Monet chose Rouen cathedral as a motif because he could paint it from inside a room overlooking a milliner's shop in the same way that Pissarro painted the Boulevard Montmartre in Paris from a hotel room.

It is easy to tough it out in bad weather when young, but Monet was aged fifty when he began the series of twenty paintings of Rouen cathedral. He had been suffering from rheumatism for over a year.

To get the most interesting results he painted the cathedral in February and March. A grey morning would give way to a sunny afternoon, which changes the local colour of the stone from grey to blue, to orange, to dull brown. Monet was an artistic thermometer who reacted to 'the most fleeting effects'. We have to imagine Monet in the upper room surrounded by numerous canvases which were adjusted as the light changed. They would be revisited the next day to create a painting that matched the previous day's lighting conditions.

The whole series of twenty paintings was taken back to the big studio in Giverny to be pondered over and repainted so that the colours of one connected to the next. Monet would have liked to see the series housed in one museum and whilst many are in the Musée d'Orsay, the series is now spread across Europe and America.

Changing weather

Do you have a window that looks out on to buildings or trees? Try painting the same subject at regular intervals, always keeping the composition the same.

You are plotting the changing light that transforms your tree or garden shed or house on the opposite side of the road. Monet would have a number of canvases at hand to capture the different effects of light as it falls on to a building, on to water or in the sky itself.

Two images of the same tree, painted under different lighting conditions.

Framing and display

Exhibitions in the nineteenth century were crowded affairs. Congestion in the galleries was matched by the crowded hang of the walls. The pictures were so close together that the traditional red walls could scarcely be seen. When the Impressionist paintings were hung in the galleries of Paris's modern art museum, the Luxembourg, in 1896, the artists complained that the pictures were hung too close together.

The indigestible jigsaws of public exhibitions had a big impact on framing. Artists needed to isolate their work from their neighbours, and so the gilded frames became wider during the nineteenth century.

The Impressionists' break with the official Salon coincided with a revolution in the installation and display of paintings. Although the English art critic John Ruskin had suggested that pictures should be hung with spaces between them, nobody at the time had taken any notice of this forward-looking suggestion – except perhaps the American painter James McNeil Whistler, who carefully designed the installation of his exhibitions in London. A suspended ceiling of light cloth and wide spacing of the pictures distinguished his exhibition from the jumble of the large mixed shows.

It was the Impressionists' pioneering break with the traditions of government-sponsored exhibitions that led to modern techniques of selling paintings. Carefully lit small rooms with paintings hung at eye level (often in a line, with space between them) was a part of the paintings being promoted and put up for sale by dealers such as Paul Durand-Ruel.

Some Impressionists took up Chevreul's notion of coloured frames, and there was a move to use white frames of a simple molding. However, neither Monet nor Renoir avoided the traditional gilded frame because buyers, even the collectors of contemporary art, felt more comfortable with less radically framed paintings.

The main difference between the exhibitions during the lifetime of the Impressionists and the exhibitions of today is the change from the dark coloured wall favoured by the Impressionists to the white rooms preferred by modern curators.

Drawing from a photograph of an Impressionist exhibition organised by Paul Durand-Ruel at the Grafton Galleries in London. Notice the simplicity of the frames and the amount of space above and below the pictures. The background colour is the traditional red.

Monet and Realism

In 1877 Monet tackled a modern subject – a series of paintings of the Gare St Lazare in Paris. He persuaded the railway authorities that it was good for business to have this Impressionist painter working in the station. In fact, he was so persuasive that he was, on occasion, able to delay the trains whilst he completed his picture.

Monet pushed to one side any desire to depict beauty, instead truthfully mapping the patterns of steam against the girders of station roof and showing the travellers waiting to board their trains. The critics were largely responsive, although some commented adversely on the brave subject matter.

These paintings were shown at the third Impressionist exhibition in 1877. In that same year, the official Salon was displaying the winner of the Prix de Rome, Chartran's *The Capture of Rome by the Gauls.*

Realism, a movement that concerned itself with things that can be seen rather than imagined, appeared in the wake of the 1848 revolution. It was a reaction to the highly polished history paintings that depicted scenes from ancient Rome or the Bible. Gustave Courbet, its champion, declared that 'painting is an art of sight', and should not concern itself with historical subjects. When asked to paint some angels for a church, Courbet replied that he had never seen an angel. Monet had met Courbet when the latter was painting landscapes in the Forest of Fontainebleau.

The Impressionist techniques developed by Monet, Renoir and their colleagues were ideal for realist subject matter – the speed of execution enabled them to freeze a moment of modern life.

Another disciple of Realism was the poet and writer Charles Baudelaire. He criticised the Salon, complaining that artists were failing to depict modern life which could be just as heroic as any events in ancient history. Both Courbet and Manet included Baudelaire in their paintings, as if to signal their gratitude for his support of their attempts to make painting relevant to a modern society.

Drawing after Monet's The Train in the Snow *(1875).*

Napoleon III departing for war against the Prussians. While the Emperor's use of the railways was symbolic of the new industrialised age, Monet's paintings of the railways were part of the new Realism, a reaction against the establishment's favoured history paintings.

EXERCISE:
Waterloo Bridge

By the beginning of the twentieth century, Monet was spending as much time re-working his canvases in the studio as he was painting direct from the motif. In many cases, he sketched in as much as he could before the light changed and then continued on another day. On other occasions he took the paintings back to Giverny, developed them further, and finally returned with them for the final session in from the subject.

This version of Waterloo Bridge is one of sixteen. The angle of the bridge was determined by Monet's view of the river from his room in the Savoy Hotel. Behind the bridge are a slender factory chimney and a shot tower in which lead shot was manufactured.

The composition may seem relaxed but it is carefully constructed with the arches leading the eye across the canvas until it is stopped by the clouds of smoke given off by a passing steam tug.

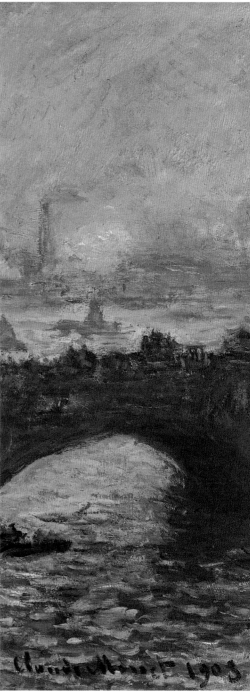

Waterloo Bridge *(1903). The Art Archive/ National Gallery of Art, Washington D.C/ Joseph Martin*

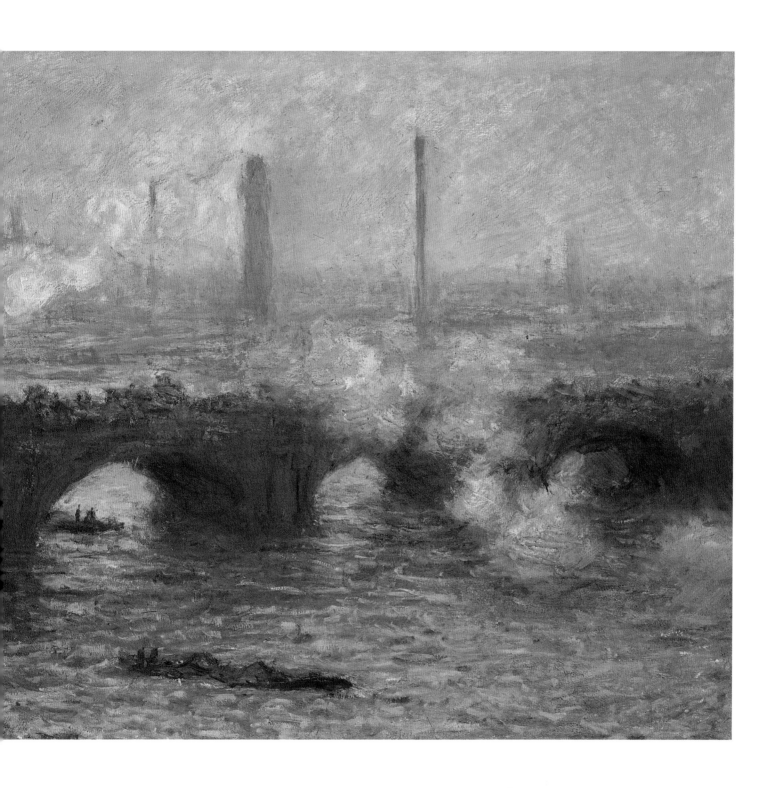

Bridges in Monet's art

Water was Monet's element, and he even voiced his desire to be buried at sea. The river Seine and its many bridges seemed to be his natural habitat. Monet was not an artist who used conspicuous symbols in his work, but his repeated depiction of bridges suggests a preoccupation with the relationship between the two banks of the river.

The artist and his creativity have been compared to a tree (by Paul Klee) and horse and rider (by Kandinsky), and so the bridge has been read as a journey from the real to the unreal. Monet, the infallible observer of nature, stressed the limitations of painting. However accurate the painting, it is still a lie because the artist's visual language has to select or sacrifice certain elements to conform to our idea of reality or simply to make the painting more effective.

The wooden bridge was a favourite subject of the Japanese printmakers whose work was hung in the dining room at Giverny. So when the water-lily pond was created, what was more natural than to build a Japanese-style footbridge? This bridge over the lily pond became an important subject for Monet's paintings, and an excellent location for photographs of the artist, his extended family, and distinguished guests.

Drawing after Monet's Argenteuil Bridge *of 1874.*

STAGE 1: AERIAL PERSPECTIVE

1. Begin with the buildings on the horizon line, using Ultramarine mixed with White. Start by blocking in the bridge in the foreground and establishing the far bank of the river. You will want to imagine where the water meets the embankment because this line will be blurred by the 'envelope' at a later stage.

2. Next, mix a little Vermilion to the pre-mixed tint for the bridge. Reserve pure Ultramarine for the inside of the arches. Make sure that the bridge obeys the rules of aerial perspective and appears darker than the banks of the Thames behind.

STAGE 2: REFLECTIONS

1. Use Cobalt Blue to indicate the reflections. The inside of the arches have been painted a lighter blue which will also be used for the reflections. The patterns of the reflections are determined by the height of the bridge and the movement of the water. Paint them in boldly with horizontal strokes.

2. Now is the moment to work up the sky. Note how Monet darkens the top right as a visual full stop moving the eye back into the central area of the painting. A thin strip of dark at the bottom of the picture serves the same purpose.

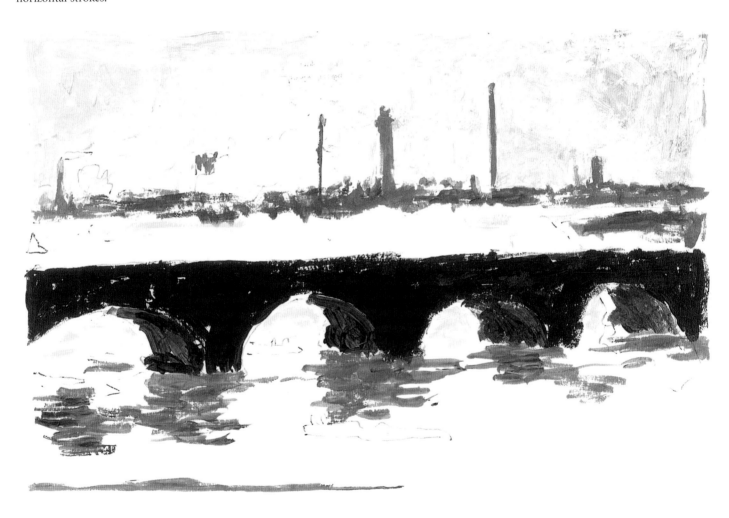

STAGE 3: THE SMOKE

1. Using pure White, dab in the smoke. Whilst wet, touch in small amounts of Alizarin around the edges where the strange greenish haze creates pinkish shadows.

2. Build the surface of the river with strokes of Pale Yellow and White on either side of the bridge.

3. Take this same mix and add small amounts of Alizarin and Emerald to make a network of reflections. If need be, cover the whole surface and go over it with White strokes.

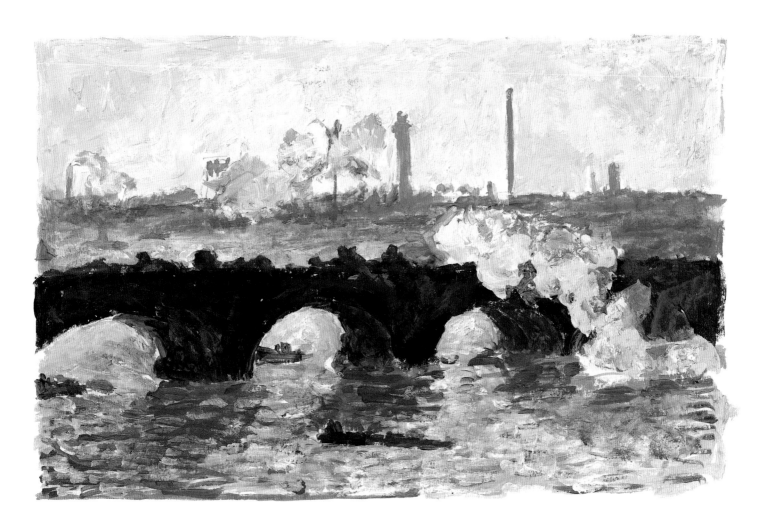

Monet's life at Giverny

The village of Giverny is some forty miles away from Paris. It had everything that Monet required – water, meadows, trees and the gently sloping hills on either side of the Seine. He loved this spot, and he suspected that it would inspire masterpieces.

Initially it was the river that fascinated Monet, for he had painted the Seine all his life and he continued to rise to the challenge. He would take two or three canvases out from the house and work in the hinterland. A change of method became evident about this time. He had already begun a series of interrelated canvases of the Gare St Lazare in 1877, but now he found a brilliant solution to the need to tramp around the countryside in search of motifs. He would choose a fixed spot and allow the light to change his static subject matter.

Some ten years after the Gare St Lazare series he embarked on the grain stacks, producing a dozen variants. To do this Monet was remarkably disciplined. He would get up at dawn, taking a cold bath before a substantial breakfast. Then he would set off in search of the motif with a wheelbarrow full of canvases. This early start was matched by an early bed at 9.30. Although his wife Alice was in charge of the domestic side of his life, Monet was a domestic tyrant who determined the timetable of the household.

The last years of Monet's life were devoted to creating his enlarged garden at Giverny, to satisfy his desire for different motifs during the different seasons of the year. This way, he had no need to step out beyond his land.

Above and opposite: Views of Monet's garden at Giverny. If Monet had not been called by the muse of painting, he would have been a professional gardener.

EXERCISE:
Water Lilies

The pond was not part of the original garden at Giverny. In 1893 Monet acquired a piece of land beyond the railway line and the river. There was opposition from the locals, but eventually he was granted permission to divert the river Epte to create his pond.

Monet now had what he had always wanted – a constantly changing motif, near to the house and near to the studio which he pretended not to have.

This picture shows the light dancing across the surface of the pond, with fronds of willow at the top framing the water whilst the lower section in shadow continues the border. Linear perspective is abandoned. Only light indicates space.

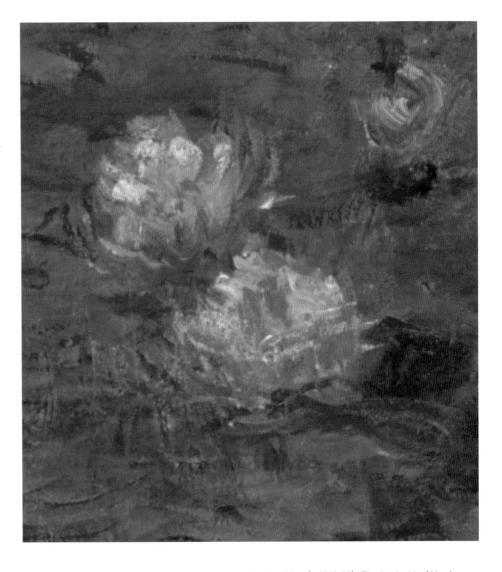

Water lilies (c.1918-25). *The Art Archive/ Musée d'Orsay, Paris/ Dagli Orti*

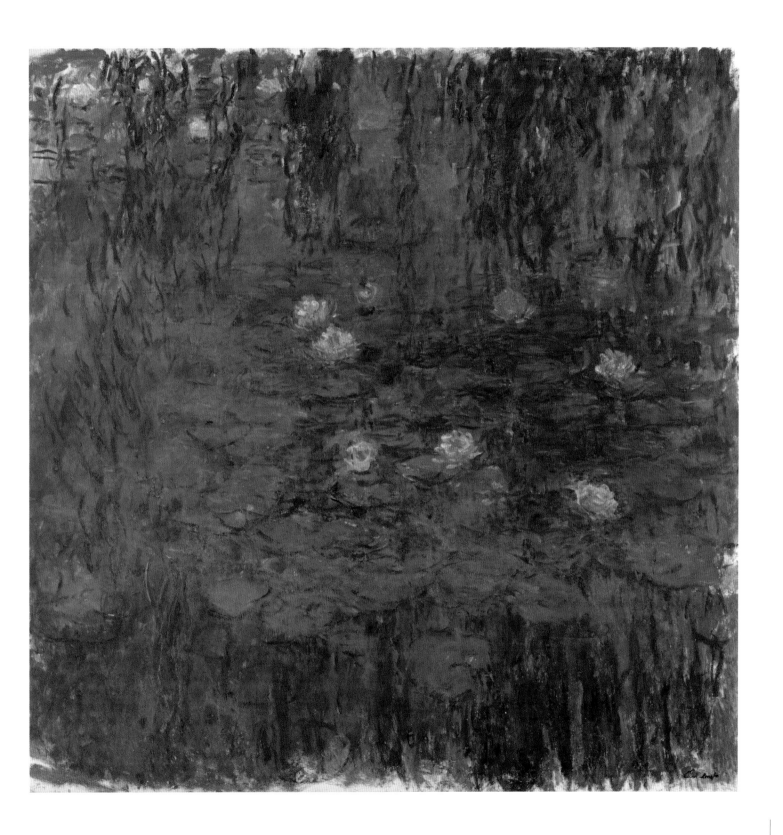

STAGE 1: MAPPING OUT THE SURFACE OF THE WATER

1. Make up a purplish blue, from Ultramarine and Alizarin Red plus White.

2. Working quickly, move around the canvas leaving spaces (reserves) for the water lilies.

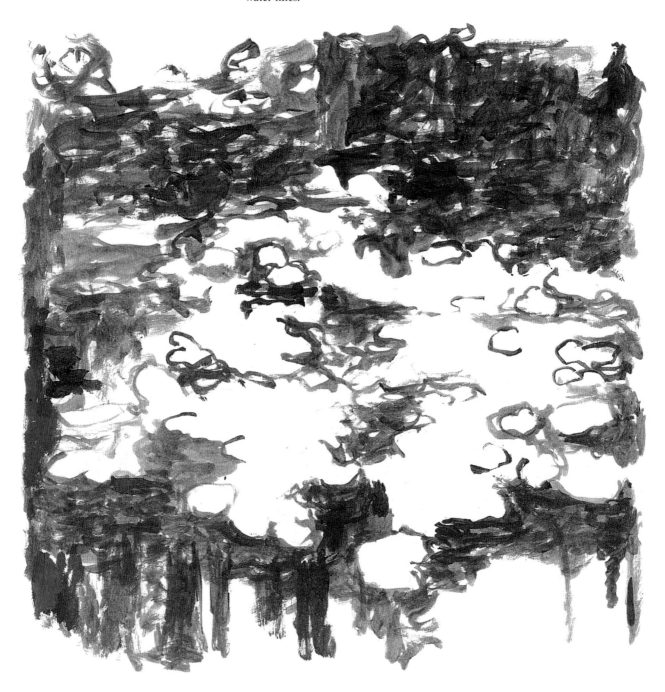

STAGE 2: PAINTING THE LILY LEAVES

1. Now go to the empty spaces and paint in the white lilies and the floating leaves with Phthalo Green.

2. Use a horizontal, vertical axis for your brush marks, in the same way the Houses of Parliament pictures were painted (see page 107).

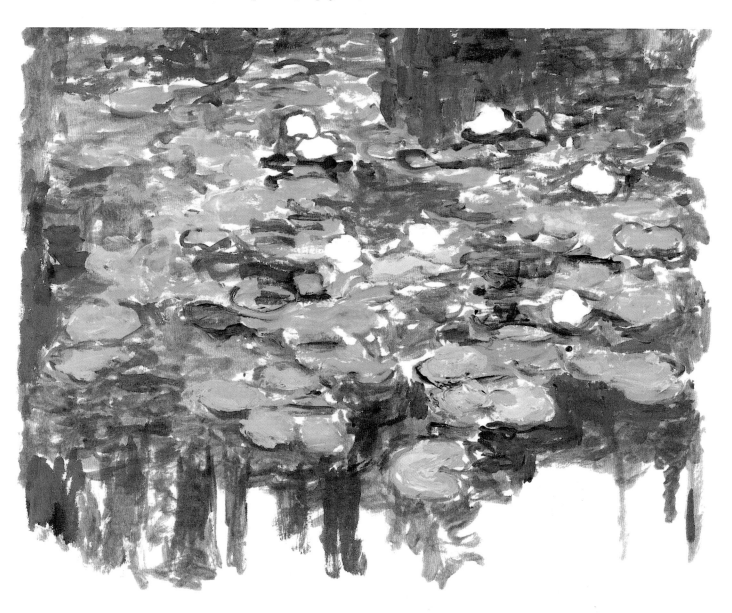

STAGE 3: FINAL TOUCHES

1. Build up the gaps between the trees and the surface of the water until a dense blue surface is created.

It is easy to recognise this image as being abstract.

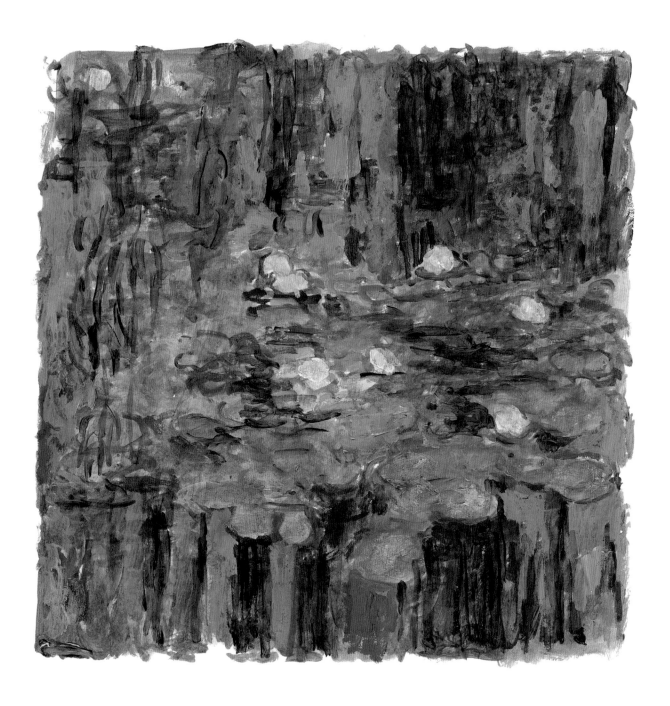

Moving the angle of your gaze

Artists set up their easels in front of their subjects so that they can look straight at the view of trees, field or the sea that they have chosen to paint. At the end of the nineteenth century, the Impressionists and those painters of the next generation that we know as Post-Impressionists – Degas, Monet, Pissarro, Cézanne and Van Gogh – broke away from this traditional manner of composing. They started to move the angle of the spectator's gaze. Degas shows us a circus acrobat from below, and he viewed his models bathing but seen from above. Monet turns his gaze towards the surface of his lily ponds. He looks downwards instead of straight ahead.

Try this for yourself. You might want to make a cardboard viewfinder to study the grass or the pavement with its lines and patterns. Looking down towards the ground reveals interesting arrangements in the way that Monet shifts our attention to the patterns made by the water lilies on the surface of the pond.

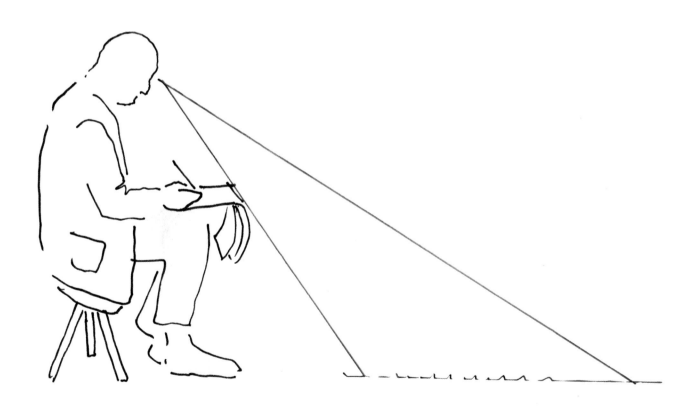

Monet's eye problems

Eye problems amongst the Impressionists were common, and it has been assumed that their habit of painting out of doors in all weathers took its toll. It is true that Degas, Pissarro, Renoir and Monet were all affected, but with the exception of Degas, age was the cause of the degeneration.

Aged seventy-two Monet was diagnosed with cataracts, but some ten years earlier he had begun to notice changes to his eyesight. He was nervous of the prospect of an eye operation, and only agreed to it when he was eighty-two. Afterwards he was fitted with specially designed spectacles which allowed him to read. He was now careful about the arrangement of pigments on his palette; he needed to know exactly where each colour was located.

The change between paintings of the garden at Giverny from 1913 and those of ten years later is startling. The later series appear to be not 'Impressionist' but 'Expressionist', due to the unrealistic colours. Foliage changes from green to red, the sky from blue to yellow.

After the operation, which corrected the colour perception of one eye, the colours return to a more natural standard. However, there are still certain effects that have been put down to Monet's disadvantaged vision. The lack of pale blue is noticeable, and in his painting of the water lilies on page 129 the lack of contrast between the violet blue background and blue trails of the overhanging willows is remarkable. Nevertheless Monet continued to paint. While his eyesight was a major problem, his general health was excellent.

A drawing of Monet's panoramic canvases installed in the Orangerie in Paris.

Monet's specially tinted spectacles.

Monet's last years

At the end of the First World War, Monet decided to donate twelve large paintings of the water lilies to the French nation. His friend, the politician Georges Clemenceau, agreed to liaise between the painter and the State. A specially designed pair of oval-shaped galleries at the Orangerie in Paris were planned to house the panoramic canvases, but Monet kept changing his mind about the donation, which greatly irritated Clemenceau.

In the meantime, Monet was issued with new spectacles but complained he could only see blue. This was countered by tinting the lenses yellow. Comparing himself to the deaf Beethoven, and in spite of his near blindness, Monet continued to paint and declared that he hoped to live to be a hundred. In the autumn of 1926, however, the bed-ridden Monet confessed to Clemenceau that

he knew he would not live to see the next spring in his garden. The cause of his despair was an inoperable tumour on his left lung, probably the result of a lifetime of smoking.

Monet died on 5 December 1926, aged eighty-six. His last communication was his gesturing of the width of the frames he wished for the panels in the Orangerie.

He was buried in the family plot in Giverny on 8 December. He left no will.

The contents of Monet's studio passed to his son Michel. The Orangerie opened the following May. In 1966 Michel died in an automobile accident. The remainder of his father's collection was willed to the Musée Marmottan in Paris.

The legacy of Monet

When the pioneer of abstraction Wassily Kandinsky visited a Monet exhibition in Moscow, he had difficulty in recognising the subject matter of the paintings. The denseness of the textured oil paint and the close-toned colours camouflaged the outlines of the grain stacks.

This experience led Kandinsky to propose a new style of art that depended on the basic visual language – colour, shape and line – but without a figurative 'subject'. Monet's envelopes of colour (the blending of object and the atmosphere that surrounds it) enabled his successors to release colour from its traditional work of labelling an object.

Under daylight a lemon is yellow, a glass of wine is red, a chair is brown, but when the seasons change or the light is tinted those local colours are modified. Painters began to experiment with colours that did not simply describe. They experimented with colours that were not merely attached to objects. In 1890, when Monet was painting the grain stack series, the French painter Maurice Denis described the route to abstraction: 'remember that a painting before being a warhorse, a naked woman or some story or other, is essentially a flat surface covered with colours assembled in a certain order'.

There are two main types of abstraction. The first is typified by the geometric, formal compositions of Mondrian and the mature Kandinsky. The second type is known as 'Abstract Expressionism'. This was a style that included the rhythmical canvases of Jackson Pollock and the softly shaped colours of Mark Rothko.

Abstract artists who paint large areas of modulated hues are known as 'colour field' painters. The arrival of many of Monet's panoramic water lily series in the United States had a huge impact on this second type of abstractionist. Looking at Monet's large, subtly coloured canvases that show neither the horizon nor even the edge of the pond, it is easy to think he had invented colour field painting. Monet's legacy can be discerned in the paintings of Helen Frankthaler and Morris Louis, amongst many others.

Monet forces us to think in terms of colour. Here two lemons differ not in their shape but in their colour, which is affected by the background of yellow or purple.

Opposite: Monet's innovative use of brush and colour has enabled artists to look at objects in a completely new way, whether their style is abstract or realist. Flowers in a Beer Mug, *by James Heard.*

Glossary

ACADEMY Organisation which combines an art school with an exhibition venue for the members. The early academies were founded in Italy during the Renaissance. By 1800 they were well established across Europe.

ACADEMIC System of teaching that formulates rules of beauty derived from a study of Classical sculpture and major figures of the Italian Renaissance such as Raphael.

ALLA PRIMA Worked in one layer of oil paint, as opposed to building up many layers.

ATELIER Another word for an artist's studio. Often used to mean a teaching space.

AERIAL PERSPECTIVE Effect created by blurring distant objects and having a corresponding lack of contrast.

BOÎTE DE CAMPAGNE Sketching easel that folds up into a paint box.

BLADDER Pigskin container for oil paint. Made redundant by the collapsible tube.

CANVAS Cloth support that may be of cotton duck or linen.

CANVAS PIN Small cylinders of wood to separate two canvases when carried. They are placed at the four corners and have a pin running through to push into the stretcher.

CANVAS PLIERS Pliers with wide flat ends to grip the canvas when it is being fixed over the wooden stretcher.

CHIAROSCURO Italian for 'light and dark', this is used to describe the contrast of tone as in Leonardo da Vinci's work.

COMPLEMENTARY COLOURS Hues that lie opposite each other on the colour circle. When mixed they make grey (with the addition of a little white). When placed side-by-side they mutually excite each other – Red / Green / Blue / Orange / Yellow / Purple.

CLAUDE MIRROR Convex mirror with a darkened glass, used to change the reflected landscape into a Claude painting with its honeyed tones.

DEAD PAINTING First layer of a traditional painting, used to work out the overall composition. When dry, thin colours are glazed over it.

DRYING OILS Walnut, poppy or linseed oil. The first two were often mixed with white oilpaint because of their pale colour.

EARTH COLOURS Hues derived from coloured earth, such as Sienna and Umber. They have good drying characteristics. Not part of the classic Impressionist palette.

EASEL Originally a Dutch word meaning donkey, it now means the wooden stand for a painting.

EBAUCHE First layer of a traditional painting, using brown and white only.

ÉCOLE DES BEAUX-ARTS Premier art school in France. Located on the left bank of Paris, opposite the Louvre.

EN PLEIN AIR Painting outside.

ÉTUDE Study from nature to be incorporated in the final composition.

ESQUISSE Small-scale composition in oil.

GLAZE Transparent coloured film of oil paint.

GROUND Preparation of the canvas before painting. A glue size is applied to seal the cloth, followed by a layer of lead white.

HISTORY PAINTING Composition with many figures illustrating a story from Ancient Greece, the Bible, Shakespeare or some other literary source. This genre of painting was considered most worthy of praise.

HUE A colour.

HOG HAIR Pig's hair, used for stiff oil-painting brushes.

IMPASTO Thickly applied paint.

LAY-IN Another term for dead colour or ebauche.

MULLER Conical-shaped stone, used to grind colours.

MOTIF The subject being painted.

MEDIUM Binding component of paint – linseed oil, acrylic or gum arabic.

PALETTE Thin, shaped board on which the artist's colours are laid out. The term also refers to the range of colours selected by an artist.

PALETTE KNIFE Flexible-bladed knife used to mixed the colours on the palette, and sometimes used to apply the paint.

PEINTURE CLAIRE Technique of painting using white with the colours to create luminosity.

PICTURESQUE Category of eighteenth-century landscape painting which usually included a ruined castle, mountains, a lake and gnarled trees.

PIGMENT Coloured particles mixed with a drying oil to make paint.

POCHADE Free, rapidly painted sketch. Monet sometimes referred to the paintings started *en plain air* as being pochades.

PRIMARY COLOURS Hues that cannot be mixed – red, blue and yellow.

PRIMING Same term as ground.

PRIX DE ROME Scholarship that enabled the winner to study in Rome. This honour more or less ensured the successful candidate a sound financial start to his career.

RAINBOW PALETTE Range of colours that matches the rainbow and excludes the earth colours. Said to be devised by Renoir.

RESERVE Leaving an empty space to be painted in later.

SALON Unofficial name given to the huge annual exhibition of paintings and sculptures selected by a jury of members of the Academy.

SALON DES REFUSÉS In 1863 the jury admitted just over 2,000 from a field of 5,000. The refused artists petitioned the Emperor, Napoleon III, who ordered an exhibition of the rejected works.

SCUMBLE Thinnish film of oil colour, containing white in its mixture, roughly applied to a dry, darker layer.

SIMULTANEOUS CONTRAST Effect of two colours on each other.

STRETCHER Adjustable wooden frame over which a canvas is stretched.

SUBLIME Eighteenth-century landscape term to describe the power of nature as a raging storm, a torrent of water or a volcanic eruption.

TACHE French word for a brush mark.

TONE Degree of light or dark in an area of colour.

WET IN WET Painting colours side-by-side without letting the first dry. Some mingling of colours will take place.

Where to see paintings by Monet

AUSTRALIA
National Gallery of Australia, Canberra
National Gallery of Victoria, Melbourne

AUSTRIA
Kunsthistorisches Museum, Vienna
Österreichische Galerie, Vienna

CANADA
National Gallery of Canada, Ottawa
Musées des Beaux-Arts, Montreal
Art Gallery of Ontario, Toronto

CZECH REPUBLIC
National Gallery, Prague

DENMARK
Ny Carlsberg Glytotek, Copenhagen

FRANCE
Musée des Beaux-Arts, Rouen
Musée Marmottan, Paris
Musée de l'Orangerie, Paris
Musée d'Orsay, Paris
Musée Claude Monet, Giverny
Musée des Beaux-Arts, Le Havre
Musée des Beaux-Arts, Lyon
Musée des Beaux-Arts, Cannes
Musée des Beaux-Arts, Dijon

GERMANY
Gemäldegalerie, Dresden
Hamburger Kunsthalle, Hamburg
Wallraf-Richartz Museum, Cologne
Neue Nationalgalerie, Berlin
Neue Pinakothek, Munich

HUNGARY
Magyar Nemzeti Muzeum, Budapest

IRELAND
Municipal Gallery of Modern Art, Dublin

ITALY
Galleria Nazionale d'Arte Moderna, Rome

JAPAN
National Museum of Western Art, Tokyo
Bridgestone Museum of Art, Tokyo
Fuji Art Museum, Tokyo
Ohara Museum of Art , Kurashiki

THE NETHERLANDS
Stedelijk Museum, Amsterdam
State Museum Kröller-Müller, Otterlo

NEW ZEALAND
Public Art Gallery, Dunedin

RUSSIA
Pushkin Museum of Fine Arts, Moscow
The Hermitage, St Petersburg

SWITZERLAND
Kunstmuseum, Basel
Fondation, collection E.G. Bührle, Zurich

UNITED KINGDOM
Courtauld Institute Galleries, London
The National Gallery, London
Tate Modern, London
Fitzwilliam Museum, Cambridge
Walker Art Gallery, Liverpool
National Gallery of Scotland, Edinburgh
Kelvingrove Art Gallery, Glasgow
National Museum of Wales, Cardiff
Ashmolean, Oxford
City Art Gallery, Southampton

UNITED STATES
Museum of Fine Arts, Boston
Art Institute of Chicago, Chicago
Brooklyn Museum, New York
Metropolitan Museum of Art, New York
Museum of Modern Art, New York
National Gallery of Art, Washington D.C.
Phillips Collection, Washington D.C.
Walters Art Gallery, Baltimore
Albright-Knox Gallery, Buffalo
Museum of Art, Philadelphia
California Palace of the Legion of Honor,
San Francisco

Bibliography

Monet, By Himself; edited by Richard Kendall (2004). A selection of Monet's letters, with a commentary and plates.

Monet: Nature into Art; John House (1986). Although out of print this is the best book on Monet, with many illustrations that reveal his painting methods.

Monet's Cookery Notebooks; Claire Joyes (1989). Monet loved his food and kept extensive notebooks of recipes that he enjoyed. This delightful book has evocative photographs of the house at Giverny.

The History of Impressionism; John Rewald (1946). Reprinted many times, this encyclopedic volume puts Monet into the context of the movement.

Art in the Making: Impressionism; David Bomford and others (1991). Originally published as an exhibition catalogue (National Gallery), the book stands on its own as a seminal survey of the methods and techniques of the Impressionists including the analysis of five paintings by Monet.

The Techniques of the Impressionists; Anthea Callen (1987). Full of details in colour and useful introductions to the chapters.

The Artists' Handbook; Ralph Mayer (1940). Regularly reprinted, this manual is essential for the serious artist.

Index

Acknowledgements and credits

The author would like to thank the following: James Burr, who may not entirely approve of the concept of this book but who gave me the opportunity to begin writing; the late Patrick Carpenter, a great teacher and an inspiring colleage; Louise and Oliver, who as children helped me to rediscover the old masters; my freelance colleagues in the Education Department at the National Gallery, London, for their insights; Elspeth Hector and her colleagues in the library of the National Gallery; my past students of the City Lit in London who asked so many questions; Miranda Harrison, my editor, who has made sense of my text and illustrations; and lastly to Annie who has put up with the stresses and strains of making this book.

Picture credits (by page number)
Art Archive: 27, 41, 47, 49, 57, 73, 75, 84, 95, 107, 113, 115, 121, 129
Bridgeman Art Library: 69

For Essential Works
Project Editor: Miranda Harrison
Proofreader: Jennifer Eisss
Design: Penny Stock / Michael Duffy
Index: Diana LeCore